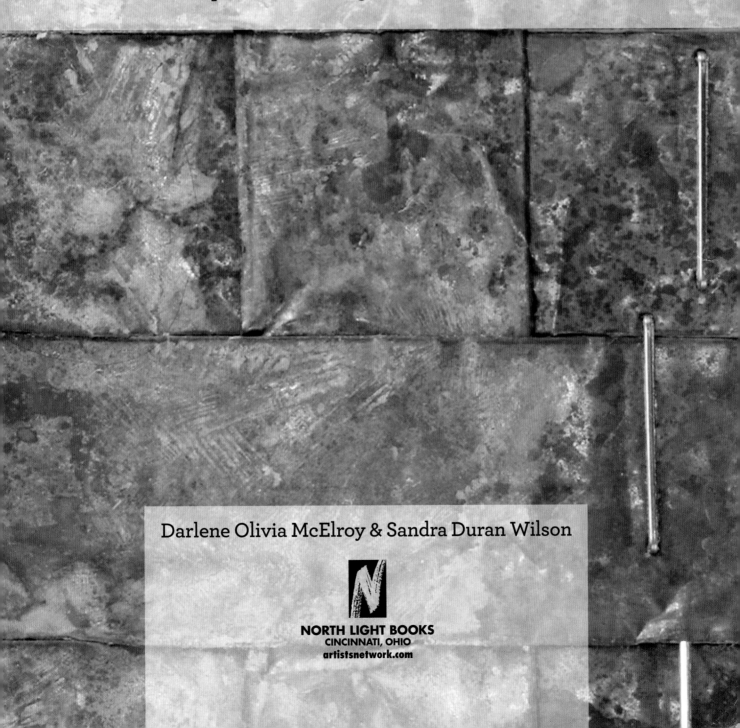

ALTERNATIVE
ART SURFACES

Mixed Media Techniques for Painting on More Than 35 Different Surfaces

Darlene Olivia McElroy & Sandra Duran Wilson

NORTH LIGHT BOOKS
CINCINNATI, OHIO
artistsnetwork.com

CONTENTS

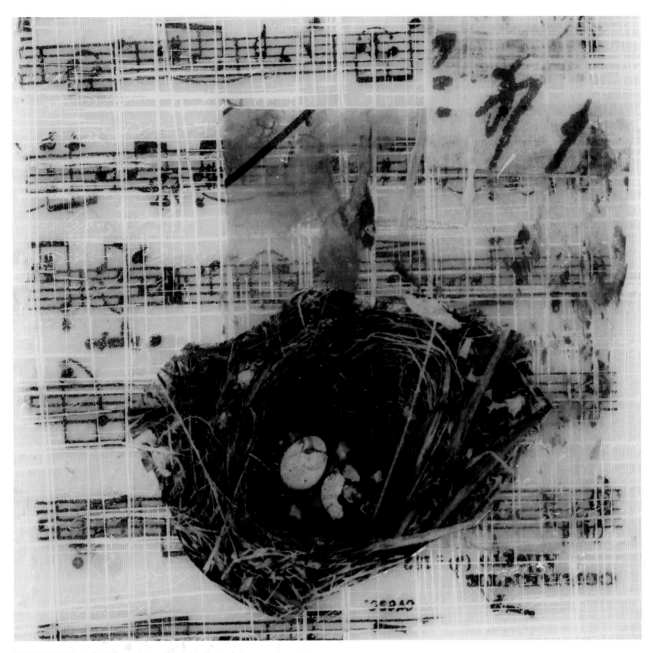

FLIGHT PLAN
SANDRA DURAN WILSON
*(Resin paper with collage paper, sheet
music and waterslide decal.)*

Want more?
Visit artistsnetwork.com/alternative-surfaces for
bonus demonstrations, tips and more.

TOOLS AND MATERIALS USED
IN THE TECHNIQUES IN THIS BOOK

For easy reference, the opening page of each chapter in this
book includes a comprehensive list of all tools and materials
used in that chapter. Don't feel like you have to acquire all of
these products at once. The techniques and projects in this
book can be mixed and matched to use what you have. Many
of the projects call for recycled materials you'll find around the
house or studio. If you have some of the items on this list and a
friend has others, get together to experiment.

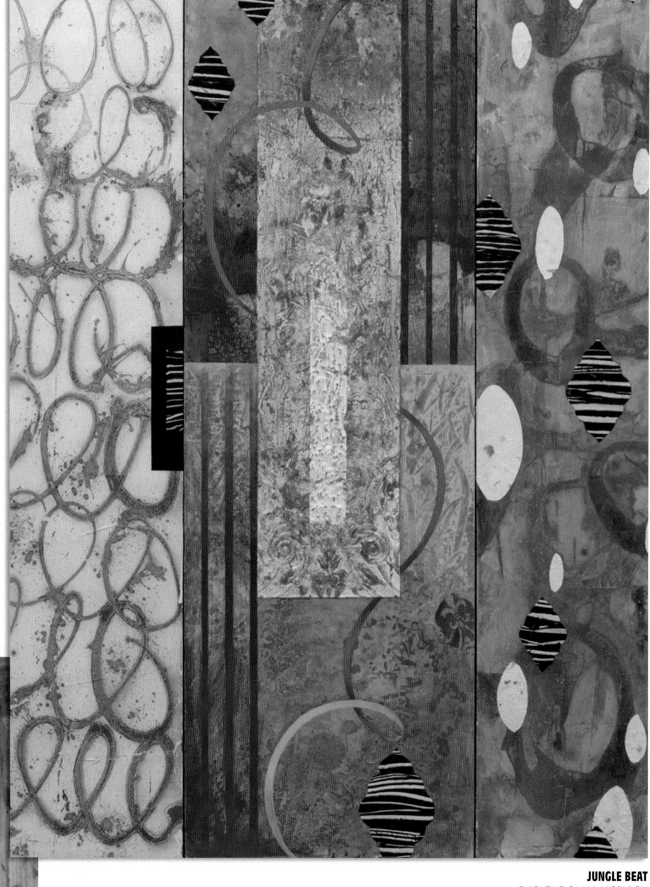

JUNGLE BEAT
DARLENE OLIVIA MCELROY
*(Gold leaf and bleach pen on painted panel,
acrylic skins and dimensional objects.)*

INTRODUCTION

For those of you who are familiar with our books, you know how much information we pack into them. This book, like our other three, is meant to give you the most information, inspiration, new ideas and techniques that we can fit between the covers. It is a compendium rather than a book that will give you all the information on one technique. We won't teach you how to carve stone, make paper or cast glass; but we will show you all kinds of wild ways to work on those surfaces and more. You will discover reverse painting on glass and acrylic, assemblage projects, sculpture, ideas for jewelry, outdoor art and functional art projects. You may even end up going in a whole new direction with your art.

We both love to try new techniques, and this book gives you that plus new ideas for surfaces on which to paint. You may have never considered painting on vinyl tiles or foam, but give it a shot and see how it can boost your creative process. This is beyond thinking outside the box. Sometimes one must stand on the box, throw out reason and archival considerations, and just do something for the fun of it—let yourself play. When teaching painting and techniques, we give much consideration to the archival qualities. This book contains some archival methods and some that are not. It is important to learn the craft and to master it, but sometimes the muse must be let loose and abandon the rules in order to freely express its creative voice. We hope you have as much fun playing as we did. Push yourself to create something new, add some innovative tools to your toolbox and expand your concepts of art.

When you take a look at museum exhibitions and cutting-edge art, you will see many art projects and installations made from materials that are temporary. Challenge yourself to find some amazing installations from cell foam or leather or resin. You will be amazed at what we artists create on and from. Let us know what you find that inspires your creative muse.

—Darlene & Sandra

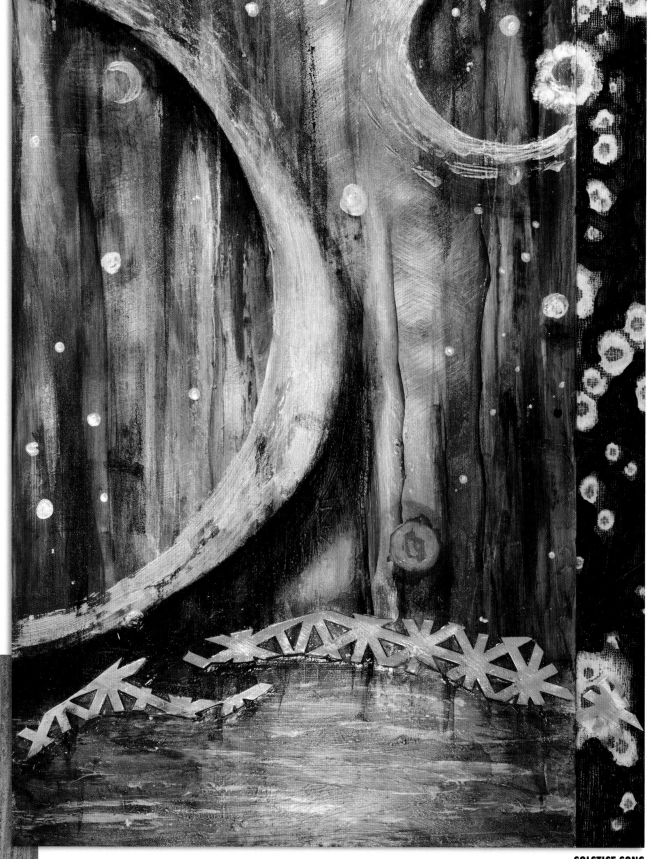

SOLSTICE SONG
SANDRA DURAN WILSON
*(Iridescent and interference paints, alcohol resist,
and metal collage on galvanized tin.)*

Visit artistsnetwork.com/alternative-surfaces for bonus demonstrations, tips, ideas and more!

1 METAL
ALUMINUM, TIN, STEEL & RUST

Metal presents an intriguing work surface because its glow and reflection add another dimension to the art. The most important thing to know about working on metal is that it requires both proper preparation and adequate curing time. If you wish to paint on a metal surface or apply transfers, stamping, patinas or resist techniques, you must follow a few ground rules. If you just want to add found metal objects to metal, then you will be mainly concerned with attaching and sealing.

Many different types of metal may be purchased online, at sign-making supply stores and at home improvement stores. If you have access to metal-cutting tools, you may cut pieces to size. If not, order them cut to the size you want.

General rules for working with all metals: Take obvious precautions, wear gloves and use eye protection. When using chemicals or patinas, work in well-ventilated areas and/or wear a mask, wear protective gloves and closed-toe shoes. Follow all manufacturers' directions.

MATERIALS AND TOOLS FEATURED IN THIS CHAPTER:

- » acetone
- » acrylic glazes and mediums
- » acrylic paints, transparent and opaque
- » acrylic spray (Krylon)
- » adhesion promoter (Dupli-Color)
- » aerosol/spray shellac (Bulls Eye)
- » alcohol inks
- » aluminum, Dibond; steel;
- » tin, galvanized
- » tin, roofing shingles, flashing
- » Chartpak solvent markers
- » cloths, rags
- » Dremel or etching tool
- » dish soap (Dawn)
- » E6000 adhesive
- » electric drill
- » fusible web
- » gel transfers
- » Golden GAC 200 acrylic polymer
- » Golden Self-Leveling Gel
- » hydrogen peroxide
- » interference paints
- » materials for mounting/ framing (wood pieces, frames, standoffs, magnets)
- » measuring cups and spoons
- » metal collage pieces
- » metal file
- » orbital sander
- » paintbrushes (quantity and sizes as desired)
- » permanent marker
- » plastic tarp or sheet
- » polymer mediums
- » protective gloves
- » regular and heavy gels
- » rubbing alcohol
- » ruler/straight-edge
- » safety goggles
- » salt
- » sandpaper (various grit)
- » scrubbing pad or steel wool
- » spray bottle
- » spray varnish
- » StazOn ink
- » tin snips
- » water
- » waterslide decals
- » white vinegar

Want more?

Visit artistsnetwork.com/alternative-surfaces for bonus demonstrations: *Creating Instant Patinas* and *Painting with Pébéo Enamel Paints on Steel.*

TIPS, TROUBLESHOOTING AND MORE IDEAS

- » You can use a Dremel or etching tool to etch or scribe into the different kinds of metal, or you can send the metal out to a vendor who makes engraving plates. Etched metal can be used to make prints, or it can become an element in a finished piece of art.
- » You can also sandblast or acid etch into metal with one of the many kits you can buy at arts and crafts stores.
- » Try spray painting on metal. You can move and drip the paint around the surface of the metal and spray from various distances to achieve an almost infinite variety of marks and patterns.

Aluminum

Getting Started

Aluminum may be purchased in different gauges or thicknesses. I like to work on metal that is thick enough to not bend easily but not so thick that it adds too much weight to my finished art. You can find plenty of sources for purchasing small sizes of cut aluminum online or from home improvement stores.

Dibond is a composite panel with an aluminum face and back and a thermoplastic core. It is a strong yet lightweight material to work on and may be found both online and in sign-making stores. It usually has a brushed finish.

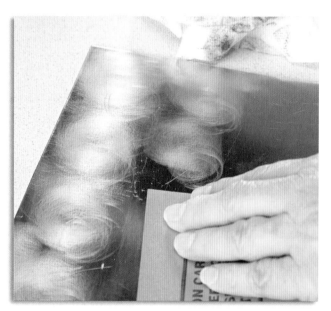

Preparing Your Surface

If your metal has sharp edges or corners, you may wish to file them so they are free of burrs. If you are going to drill into your metal, do so before proceeding with priming or other work.

I have experimented with different techniques and products to ensure good adhesion. Begin with a soap-and-water washing. Dawn dish soap works great for cleaning off surface oil. If the aluminum sheet is plain and not brushed aluminum, I will gently abrade the surface. I may use a Scotch-Brite scrubbing pad, extra-fine steel wool or a fine grit sandpaper (like a 600-grit, for example). Rinse after washing and abrading, and then wipe the metal with rubbing alcohol and a clean cloth. Avoid adding fingerprints to the surface of the cleaned metal by handling it only by the edges.

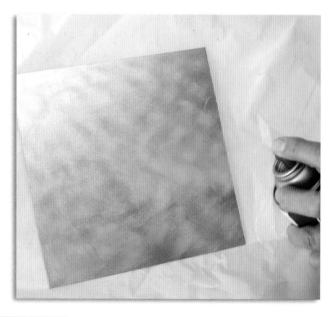

Priming

I recommend spraying your aluminum panel with Bulls Eye shellac. Other brands of shellac will work as well, but I know I get the results I want when I use Bulls Eye. I've also experimented with Krylon acrylic spray and Dupli-Color adhesion promoter. Follow the manufacturers' directions for all products you use, and spray aerosols only in a well-ventilated area. Generally, two coats should be enough. Be sure to rotate the piece between applications. Let your primed piece dry completely and cure overnight before proceeding.

Painting

For aluminum painting, I suggest alcohol inks, transparent acrylic paints, acrylic glazes and acrylic mediums. These more transparent colors allow the reflective quality of the metal to shine through. Adding more opaque colors or mediums creates a wonderful yin and yang in the finished art. Surface techniques like salting and alcohol resists add tons of interest. (Pick up a copy of *Surface Treatment Workshop* for everything you could ever want to know about surface treatments.) If you wish to increase the transparency of your paint while increasing adhesion, add Golden GAC 200 to your paint. Mix the paint into the medium to have more control over the final paint color. Keep in mind that

GAC 200 is white out of the bottle but will dry clear. Make your color adjustments accordingly.

The most important thing to remember when painting on aluminum is that you must let the paint dry and cure sufficiently before proceeding with any additional steps or techniques. Acrylic paints and products will dry to the touch very quickly, but they need a few days to cure completely. One day may be OK, but three days is better. Of course, temperature and humidity will affect drying time. As the car people say, your mileage may vary.

(The painting above features alcohol inks, acrylic paint mixed with Golden GAC 200, stamping with StazOn ink and more paint. Image by Sandra Duran Wilson.)

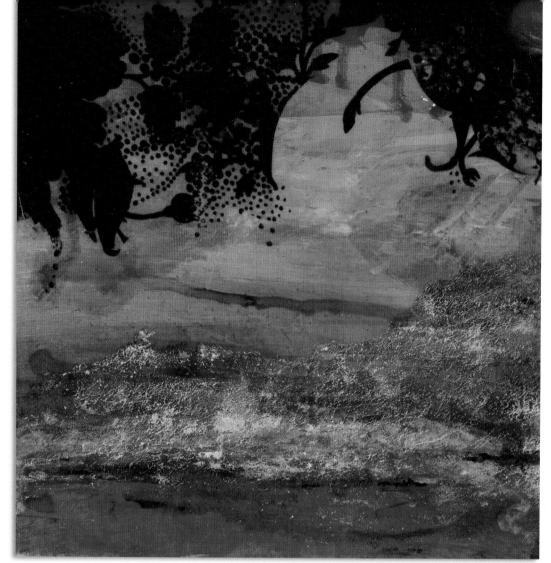

SUNSET
SANDRA DURAN WILSON
(Using transparent layers of paint, collage materials and transfers provides the best depth and allows the reflective quality of the aluminum to shine through.
Aluminum painted with acrylic glazes and alcohol inks, painted fusible web and a Papilio waterslide transfer near the top.)

Transfers

A waterslide decal can easily be included in an aluminum-based painting and can be added at almost any point during the overall process. You see an example at the top of this painting.

You could also do a solvent transfer—with a Chartpak solvent marker, for example—but this would need to be added prior to priming.

A gel transfer can be a bit tricky, but it can be done; be careful not to rub the entire transfer off. White or lighter colors will allow the aluminum surface to be seen through the transfer.

Collage

I have added a piece of hand-painted fusible web to the bottom part of this painting, but you can collage almost anything to aluminum. I recommend collaging materials using a polymer medium gloss. You want to match your glue to the weight of what you are adhering. If you are gluing a thin paper, polymer medium works well. For heavier papers you would use a regular or heavy gel.

Final Finish

Finish your aluminum painting by adding a diluted layer of Golden Self-Leveling Gel.

Mounting and Display Options

Your finished aluminum art may be framed and hung as is. One of numerous options is to cut and glue wood strips to the back of the aluminum to give it a cradled-board look. Use a glue for wood and metal; E6000 works well.

Galvanized Tin

Purchase galvanized tin roofing shingles, also known as flashing, from a home improvement store. They are lightweight, flexible, inexpensive and fun to work on. (See finished piece, *Solstice Song*, on page 6.)

Preparing Your Surface

Prepare galvanized tin the same way you would aluminum, including sanding the surface. Sanding before painting provides a light texture that will glow through the paint. An orbital sander will give you a circular sanded pattern, or you can sand your tin by hand using a circular motion.

To cut galvanized tin, mark your cut line with a permanent marker and cut with tin snips.

TIPS, TROUBLESHOOTING AND MORE IDEAS

Poured satin or matte finishes have better adhesion to the metal. If you wish to unify your final surface sheen, spray it with a varnish spray. Spray in thin layers only and let each layer cure for a few days.

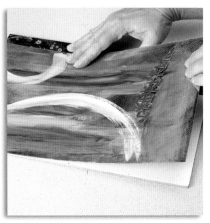

File burrs and sharp edges with a metal file.

Painting

You can use the same types of paints you would use with aluminum. Again, I recommend adding GAC 200 to your paints. Use transparent and interference paints for extra "glow."

Embellishing

You can also collage metal pieces to your tin. Buy decorative pressed or cut tin from a home improvement or hardware store and cut it into smaller pieces with tin snips. Use E6000 to glue the pieces to your tin surface.

Mounting

Mount the metal to a painted board with E6000. Finish with additional paint, if desired, and a pourable acrylic medium to alter the sheen or add depth.

Instant Rust & Patina on Steel

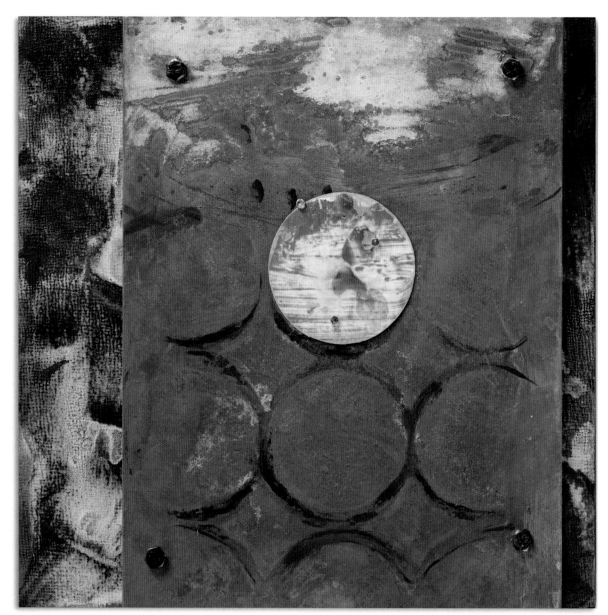

Mounting
Standoffs are a great addition to this piece. I've used them to attach a rusted piece of steel to a painted board. They add dimension and shadow, and I love the look. I also used magnets to hold some patina papers in place. Interactive art!

Preparing Your Surface
Steel sometimes comes with a coating that may have to be removed with acetone. First try to wash the steel with soap and water and then clean it with alcohol. If it still has a film or a greasy feeling, use acetone to clean it. File the edges to remove any sharp corners or burrs.

If you need to drill the metal, do so prior to painting or adding patina.

EVOLVING
SANDRA DURAN WILSON
(Paint and patina on wood panel. Rust applied over steel. Deli paper coated with paint and patina kit. Metal and panel were drilled and offsets were used to mount the metal over the panel. Rare Earth magnets were used to hold the deli paper in place.)

Instant Rust

Here's an easy recipe for using vinegar, salt and hydrogen peroxide to induce rusting without using specialty kits or products. Don't you just love kitchen chemistry?

Begin with clean metal, or remove any paint and degrease. Sand the surface and wash with Dawn dish soap to degrease the steel. Do not touch the surface after you have degreased it (or you will risk adding fingerprints to the metal).

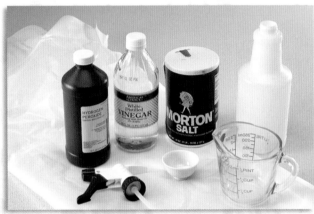

1 Mix up a batch of rust accelerator, adding ingredients in the order noted:
- 16 ounces (450g) hydrogen peroxide (use a fresh bottle)
- 2 (60g) ounces white vinegar
- ½ tablespoon (20g) salt

Mix all the ingredients together and shake well to dissolve the salt.

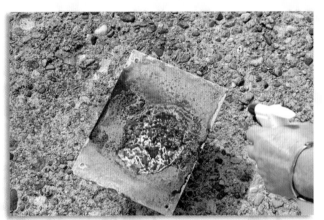

2 Move outside for the rest of the process. Place the steel on a piece of plastic and spray it with the mixture. Make sure you wear safety goggles and protective gloves. Don't do this on a windy day. Let the surface dry.

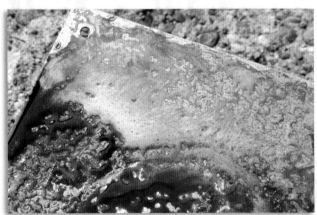

3 Spray the steel repeatedly, allowing it to dry between applications. The more applications, the more the steel will rust. If it doesn't rust, then you didn't degrease it enough, or you didn't spray it enough. You may have to repeat one or both of those steps. Another possibility is that the outdoor temperature was too cold. This process works best at

warm temperatures. It also helps to let the object sit in direct sunlight and heat up a little before the first application. Let it dry and repeat. Keep spraying and drying until you are satisfied with the degree of rusting. The rust on the surface is delicate, so take care not to touch it at this point. You may wish to seal the surface with an acrylic spray or polyurethane.

Visit artistsnetwork.com/alternative-surfaces for bonus demonstrations, tips, ideas and more!

2 METAL LEAF

There is a magic in metal leaf that allows it to work well as a background, an accent or a focal point. As you walk around your art, it changes as the light reflects on the leaf. There is real gold and silver leaf, but also imitation leaf, which comes in many colors and variations and is less expensive. Different brands and even batches may have color shifts. Joss paper can work as an inexpensive alternative you can use in some cases. Metal leaf can be sanded back to dull it and show any surface interest that is underneath, layered and tarnished.

MATERIALS FEATURED IN THIS CHAPTER:

- » acrylic gel and glazing mediums
- » adhesive size
- » crackle paste
- » dry sponge
- » embossed faux leather or wallpaper
- » everyday or found objects
- » fabric and thread
- » gel bleach/pen
- » glass bead gel
- » Golden Digital Ground
- » inkjet printer
- » Joss paper
- » Krylon Crystal Clear
- » liver of sulfur solution
- » metal leaf: gold, silver, imitation
- » mineral spirits-based acrylic varnish (Golden Archival Varnish spray)
- » molding paste
- » needle or sewing machine
- » paintbrushes
- » paper towels
- » patina solution
- » Plexiglas, glass pane or mirror
- » printer/carrier paper
- » rubber stamps
- » rubbing alcohol
- » sandpaper
- » small-nosed bottle
- » soft brush
- » soft gel gloss
- » spray bottle
- » spray glue
- » stencils
- » waterslide decal
- » workable fixative

THE BASICS OF METAL LEAFING

Preparing Your Surface

All leaf will tarnish with time unless it is properly sealed. The exception is imitation silver, which is really aluminum. Golden Archival Varnish spray is recommended for sealing after leaf has been applied.

Applying

There are many ways to apply metal leaf (see *Surface Treatment Workshop* for suggestions), but the simplest of techniques is a fine option. Traditionally, gold leaf is put on a red oxide surface, and silver leaf on a celadon-colored surface, but really, anything goes.

It is easier to use nonpaper-backed leaf by placing wax paper over it. The static will temporarily adhere the leaf to the wax paper, thus making it easier to position on your art. Rub to release the metal leaf onto a sized surface.

Apply the adhesive size on your painted surface. It goes on white but turns clear when tacky and ready for the leaf to be applied.

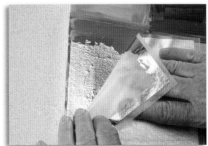

Lay down your metal leaf (here I'm using a paper-backed leaf) and pat down.

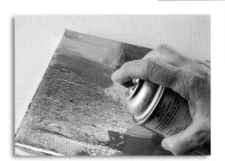

Brush off excess leaf with a soft brush. To seal, spray with a mineral spirits-based acrylic varnish.

Changing the Ordinary to Extraordinary

Take an everyday object, apply metal leaf and suddenly you have something extraordinary. It could be a wishbone, an old Barbie doll, your old, dead paintbrushes—you get the idea. Wow, the ordinary becomes extraordinary.

TIPS, TROUBLESHOOTING AND MORE IDEAS

Spray lightly so you don't get soupy areas that will never become tacky enough to hold the leaf.

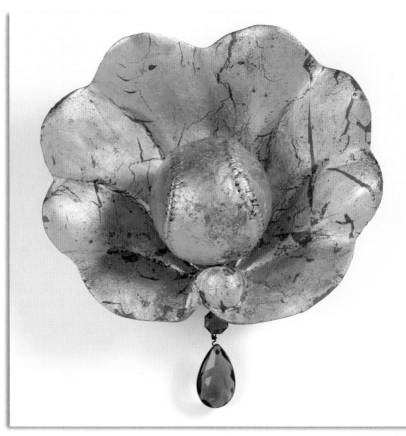

GOLDEN CATCH
DARLENE OLIVIA MCELROY
(Wood bowl, baseball, glass pendant, metal leaf.)

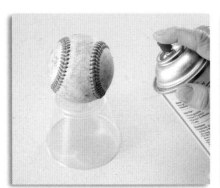

Apply spray glue to your everyday object.

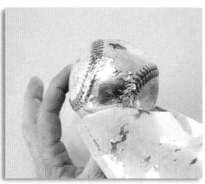

Apply metal leaf.

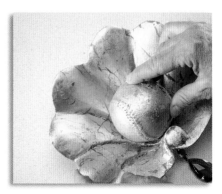

Seal with a mineral spirits-based spray varnish.

Bleach, Patinas & Liver of Sulfur on Leaf

Preparing Your Surface

Gel bleach tarnishes and eats through metal leaf in interesting and unpredictable ways, and it usually exposes painted color beneath the leaf. The longer you leave gel bleach on your leaf, the more dramatic the results. Another option is to try playing with a patina or liver of sulfur for similarly interesting results.

TIPS, TROUBLESHOOTING AND MORE IDEAS

Please do these techniques outside or in a well-ventilated room!

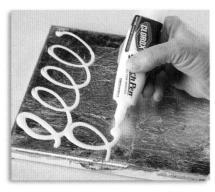

Draw, stamp or paint with gel bleach on your leafed surface. The surface should be unsealed.

Let the gel sit for several hours and then wipe it off with a damp paper towel or baby wipe.

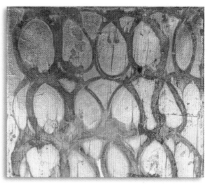

Pat the surface dry, and then seal your piece with a mineral spirits-based spray varnish.

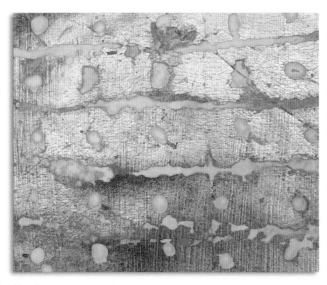

Patinas
Brush on a patina solution and wait several hours for maximum effect.

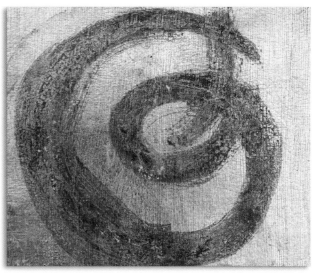

Liver of Sulfur
Brush a liver of sulfur solution on and watch it tarnish the leaf. This has a strong smell, so do it outside or in a well ventilated area.

Further Experimentation

Try these fun techniques. Remember to always seal your leaf with a mineral spirits-based spray varnish.

Stamping
Apply with a stamp. Then apply leaf and rub off excess with a dry sponge.

Speckled
Spray alcohol on thin wet paint that has been applied over cured leaf.

Stenciling
Add a stenciled design or image with paint, gels or crackle paste. Glass bead gel was used here.

Sanding
Sand metal leaf on a textured surface (here, a crackle surface) so the base colors show through.

Grunge/Corroded
Drag course molding paste across the metal leaf. When dry add a wash of iridescent bronze paint.

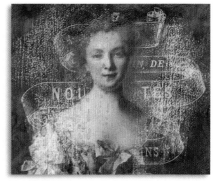

Transfer
Apply a waterslide decal onto a metal-leafed surface. When the decal and surface are dry, you can sand back the decal or add paint.

Glazing
Add glazing medium or soft gel gloss to your paint, and paint on your metal-leafed surface.

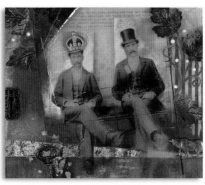

Plexiglas
Apply metal leaf to the front and back of a piece of Plexiglas. Add collage elements and image transfers as desired.

Fabric
Spray glue through a stencil (we used a homemade one) onto fabric and then apply metal leaf. Seal the leaf and then sew or stitch a design into the leaf.

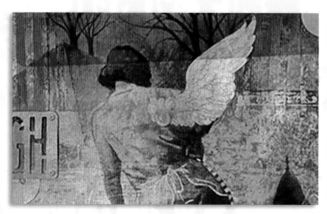

Print

Apply Golden Digital Ground to Joss paper, and let the digital ground dry. Then attach the paper to a carrier sheet. Print on the Joss paper with an inkjet printer. Spray with workable fixative to set the printer ink.

Screening

Spray glue through a stencil and then apply metal leaf. Rub off the excess leaf with a dry sponge. Variegated leaf is shown here.

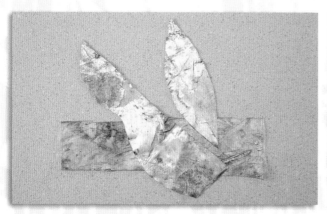

Skin

Make a skin by layering metal leaf between two layers of acrylic gel and allow to dry. (See chapter 15 for more on making acrylic skins.) Cut the skin into shapes or make mosaic pieces.

Bleach

Apply gold leaf onto a vintage mirror. Draw or write using gel bleach and then wait several hours. Wash off the remaining bleach and spray with Krylon Crystal Clear to seal.

Aged

Apply gold leaf onto embossed faux leather or wallpaper. Apply dark brown paint and wipe it off so it remains only in the embossed depressions.

Writing

Fill a small-nosed bottle with adhesive size and use it to write or draw. Apply gold leaf and rub off any excess with a dry sponge.

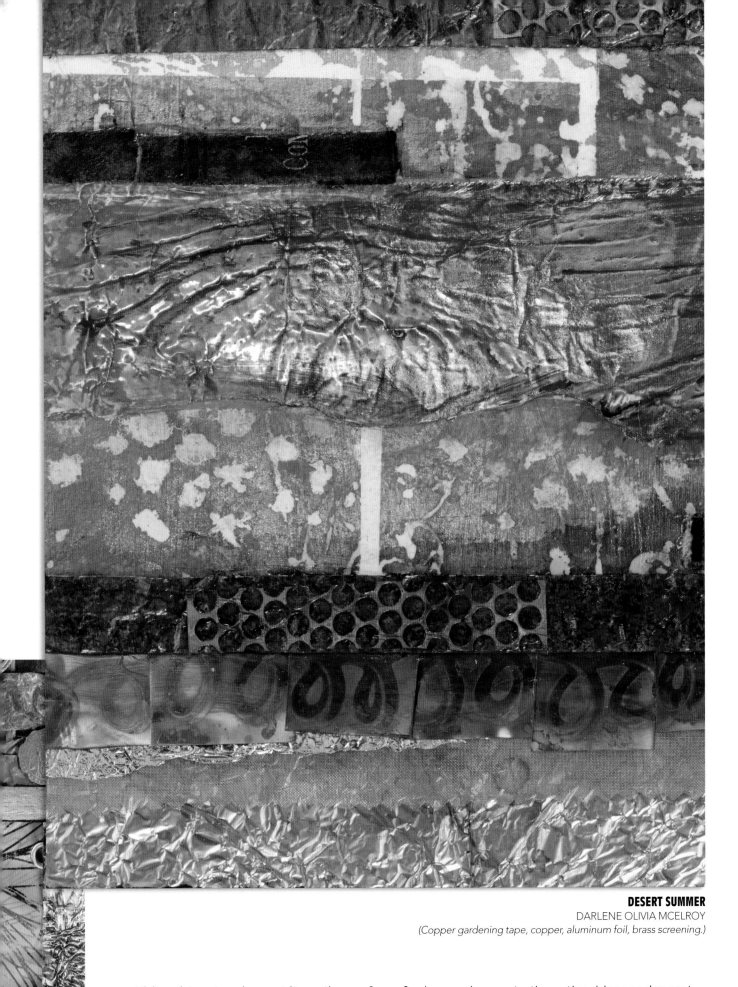

DESERT SUMMER
DARLENE OLIVIA MCELROY
(Copper gardening tape, copper, aluminum foil, brass screening.)

Visit artistsnetwork.com/alternative-surfaces for bonus demonstrations, tips, ideas and more!

3 METAL FOIL, SHIMS & SCREEN

This shimmering collage element adds drama to your painting as an accent, or you can create a patchwork quilt of metal foil that has been painted, embossed or printed on. The techniques that you can apply to this substrate are unlimited.

MATERIALS FEATURED IN THIS CHAPTER:

- » acrylic paints
- » alcohol inks
- » brayer
- » copper or imitation copper leaf
- » embellished metal pieces
- » gel bleach/pen
- » glazing and transparent paints
- » glue appropriate for metal
- » Golden Digital Ground
- » grommets
- » hanging wire
- » inkjet printer
- » jump rings
- » masking or other tape
- » metal foil, shims and screen
- » paintbrushes
- » paper towels or baby wipes
- » permanent markers
- » printer/carrier paper
- » rubber stamps
- » sandpaper
- » scissors or tin snips
- » scribing tools
- » self-leveling or soft gel
- » silicone adhesive
- » soda can
- » soft gel matte
- » sponge, sponge brush
- » string or thread
- » substrates such as wood panels
- » texture plates
- » thrift store frames, drawers
- » workable fixative

Preparing Your Surface

- Many metals have a coating that may need to be sanded off.
- Copper has become more expensive recently, but you can create a faux copper look by applying an imitation copper leaf to an aluminum-wrapped surface.

Metal Shim and Screen Collage

Use any variety of techniques featured in this chapter to create a unique metal-pieced collage or wall hanging.

Gather a cohesive assortment of embellished metals for your collage.

Using soft gel matte and/or a silicone adhesive, glue pieces down until the substrate is completely covered in an arrangement you enjoy. Allow the gel to dry completely.

Embossing

Depending on the weight or type of metal you are using, you can emboss it for a very textured look. Scribe into your metal with a rounded tool, embossing tool or crochet hook, stamp into it, lay it over a deep textured surface and brayer it. If you paint the metal with a dark paint after embossing it and then wipe off any excess paint, the grooves and gouges will show up well.

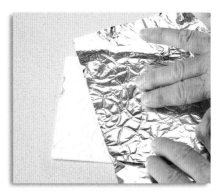

1 Lay lightweight shim or foil over a strong texture and brayer it. You can use a sponge or your hand if you don't have a brayer.

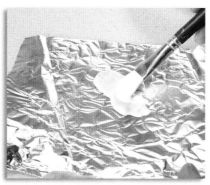

2 Flip the shim over and lightly spread a layer of self-leveling or soft gel on the back of the shim to harden the shim and to hold the texture.

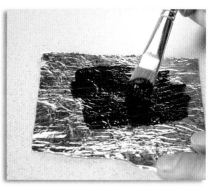

3 When the gel is dry, you can add paint to the front of the shim.

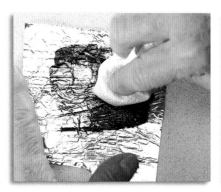

4 Wipe off any excess paint while it's wet for a look that is more stained than painted.

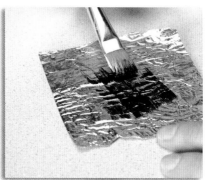

5 Or drybrush paint on the surface to pick up just the highlights of the embossing.

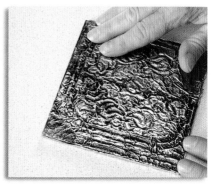

6 You can glue the shim onto a backing piece or cut it into shapes before gluing it onto another piece.

TIPS, TROUBLESHOOTING AND MORE IDEAS

Make sure any self-leveling gel you apply has dried completely before applying a stain or paint. If you fail to do this, your embossed area will flatten out.

Mark Making & Stamping with Bleach

Draw or write on the metal shim, or stamp on it with gel bleach or a gel bleach pen. It is a great look and easy to do.

Bleach Pen or Gel Bleach

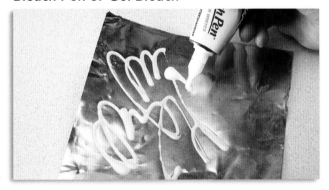

Draw or write on the metal shim with a bleach pen or gel bleach.

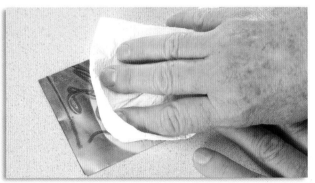

Wait several hours and then wash off the bleach and blot.

TIPS, TROUBLESHOOTING AND MORE IDEAS

» The final look varies depending on how long the bleach is left on the metal.
» Try writing on copper gardening tape to create unique, fun accent pieces.

Stamping with Gel Bleach

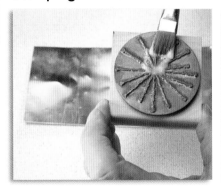

Brush gel bleach onto a rubber stamp with a bold pattern.

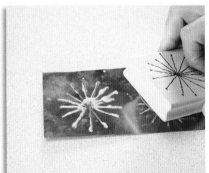

Stamp the bleach onto a metal shim.

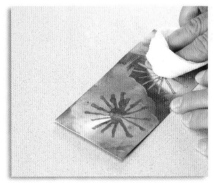

Wait several hours and then wash off the bleach. Blot the metal dry.

TIPS, TROUBLESHOOTING AND MORE IDEAS

» The look varies depending on how long the bleach is left on the metal.
» Apply gel bleach to the highlights of your stamp with a sponge brush, or stamp into a paper towel soaked in gel bleach to replicate the best detail of your stamp.

Soda Can Printing

Create a nice, thin shim on which to print by cutting up a soda can. It sounds harder to do than it actually is. Once you've printed on your do-it-yourself shim, be sure to spray it with a workable fixative.

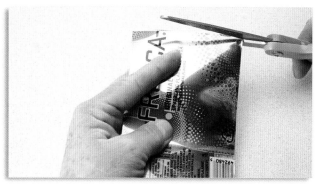

1 Cut off the top and bottom of the can and trim the edges.

2 Apply Golden Digital Ground to the inside of the can. This is the side you'll be printing on. Let the Digital Ground dry.

3 Attach the can to carrier paper and tape it in place along the top and all corners. Run the "packet" through the printer.

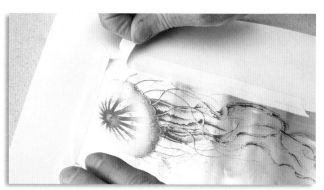

4 Carefully remove the tape from the can and carrier. Spray with a workable fixative.

Painting
Try painting metal with alcohol inks, acrylics or markers to discover your style and preferences.

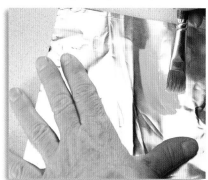

Glazing and transparent paints allow the metal glow to show.

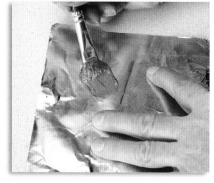

An opaque acrylic paint will obscure the metal but can be etched into or sanded back when dry.

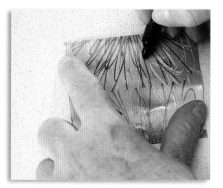

Draw on the metal with permanent markers for a hand drawn look.

Wall Hanging

Cut, embed and collage metal pieces to make a unique piece of hanging art. You can attach the metal pieces to a base by using grommets, sewing, stapling or gluing. Put the metal pieces in a frame, or attach them to a found object for interest. Think of this piece as a wall brooch or wall jewelry.

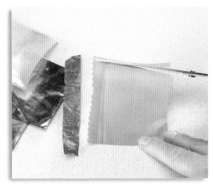

1 Cut out shapes of metal foil and metal screen for your design.

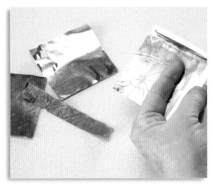

2 Use some of the many techniques illustrated earlier in this chapter to embellish the foil and screen pieces.

3 Add grommets to each piece of metal.

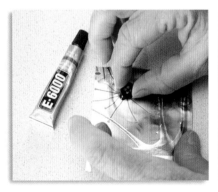

4 Glue miscellaneous objects onto the metal pieces as desired.

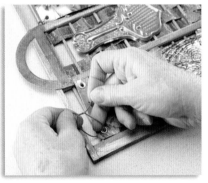

5 Tie with string or thread, or add jump rings to connect all the pieces to a base.

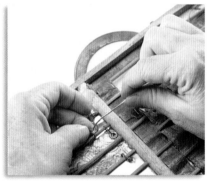

6 Add a hanger to the back of the finished wall hanging.

TIPS, TROUBLESHOOTING AND MORE IDEAS

» Sand the metal pieces so they have tooth for the glue to adhere to.
» If you are ambitious, this could be a window covering or a room divider that tells a story using found objects or items that are special to you.

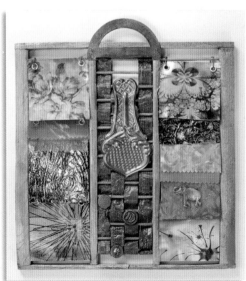

DESERT SUMMER
DARLENE OLIVIA MCELROY
(Copper gardening tape, copper, aluminum foil, brass, copper screening, brass objects placed into the bottom of a bird cage.)

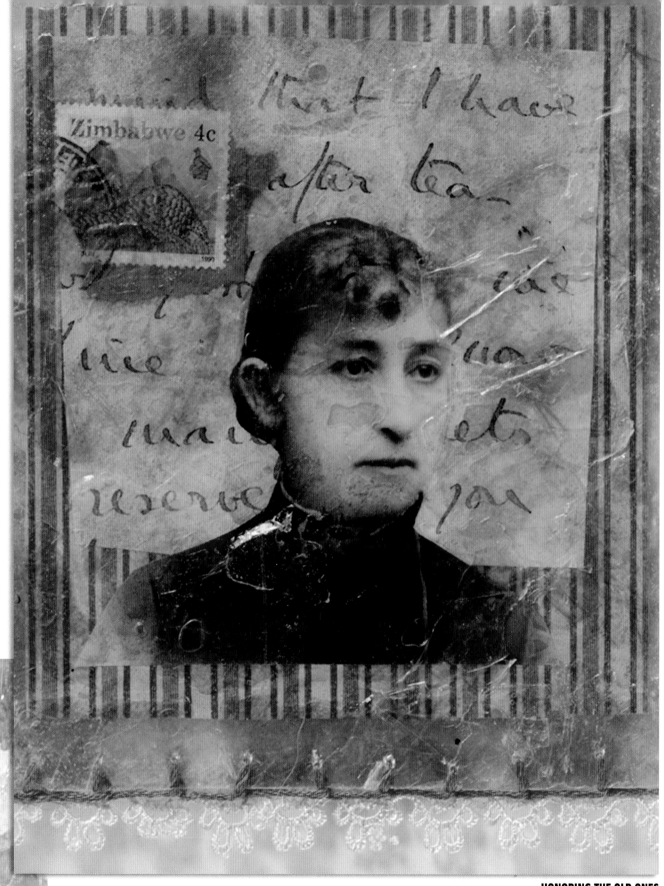

HONORING THE OLD ONES
DARLENE OLIVIA MCELROY
(Mica, vintage ephemera.)

Visit artistsnetwork.com/alternative-surfaces for bonus demonstrations, tips, ideas and more!

4 MICA

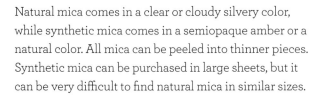

Natural mica comes in a clear or cloudy silvery color, while synthetic mica comes in a semiopaque amber or a natural color. All mica can be peeled into thinner pieces. Synthetic mica can be purchased in large sheets, but it can be very difficult to find natural mica in similar sizes.

Both are easy to cut and can be backlit for special effects. You can sandwich very thin objects and images between several layers. You can also purchase mica powder, which is like a natural glitter.

MATERIALS FEATURED IN THIS CHAPTER:

» cardboard box or box canvas, 4" × 4"(10cm × 10cm)
» craft knife or scissors
» drill
» ephemera
» fiber paste
» found objects such as buttons and shells
» masking or painter's tape
» mica (natural or synthetic, sheets or powder)
» paintbrush
» polymer medium gloss
» polypropylene plastic sheet
» soft cloth
» soft gel gloss
» stencils
» strong glue
» yarn, string, lace, ribbon

Preparing Your Surface

Clean dust or debris off of mica with a soft, damp cloth.

Want more?

Visit artistsnetwork.com/alternative-surfaces for a bonus demonstration: *Making Patterns with Powdered Mica.*

Making Larger Pieces

Small pieces of mica are nice, but big is better.
This technique allows you to make sheets that are
also more transparent.

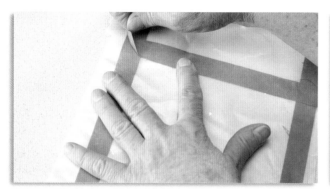

1 Tape off an area on a big sheet of thin
polypropylene plastic.

2 Paint a layer of polymer medium gloss onto the
plastic and let it dry.

3 Apply soft gel gloss, lay pieces of mica into the gel
and let dry thoroughly. This could take a couple
of days.

4 Peel the mica "skin" off the plastic.

5 You can now cut the mica in shapes, or leave to
use in another project.

TIPS, TROUBLESHOOTING AND MORE IDEAS

» If it is taking too long for the mica skin to dry,
lift one edge to let air get underneath it. You may
have to do this several times over a few days.
» You may have to add more gel to the top of the
mica after step 3 if it isn't lying flat.

Laminating

Seal ephemera between layers of mica to create a contemporary artifact.

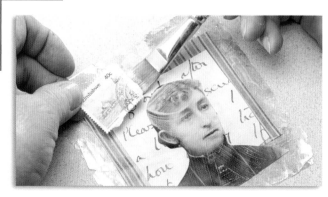

Apply soft gel gloss to your mica. Add ephemera and let dry. Here I'm adding patterned paper, a handwritten letter, a photo and a stamp.

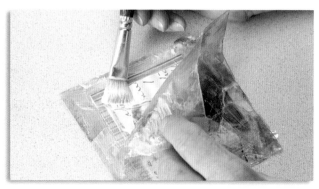

Apply soft gel gloss to the mica and put a second piece of mica on the first piece, sandwiching the ephemera. Let dry.

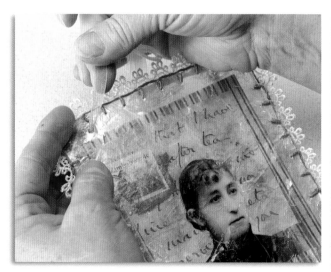

Drill holes in the top of the mica if you are going to hang the piece or use it as jewelry. I also drilled holes all around the piece and blanket-stitched through the holes to add a vintage flair. I used soft gel to adhere lace to the perimeter. To finish, insert a piece of ribbon through the punched holes and tie for a hanger.

TIPS, TROUBLESHOOTING AND MORE IDEAS

Make sure you use flat images (like book pages, photos, string, glitter, etc.) between layers of mica. If you use bulky items, it will look like a funky pouch (and not in a good way!), and your layers will not seal properly.

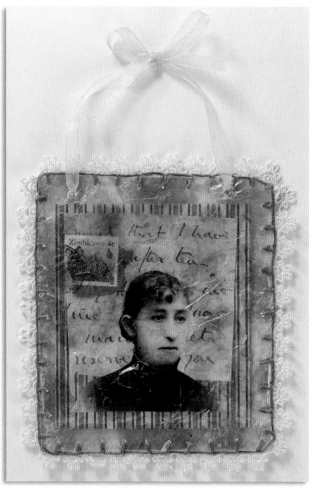

Sculpture

You can make a beautiful translucent sculpture with mica and added stencils and objects. (You can print a full-size template for the mica house at *artistsnetwork.com/alternative-surfaces*.) Use either a craft knife or scissors to cut out the shapes, depending on how thick your mica is.

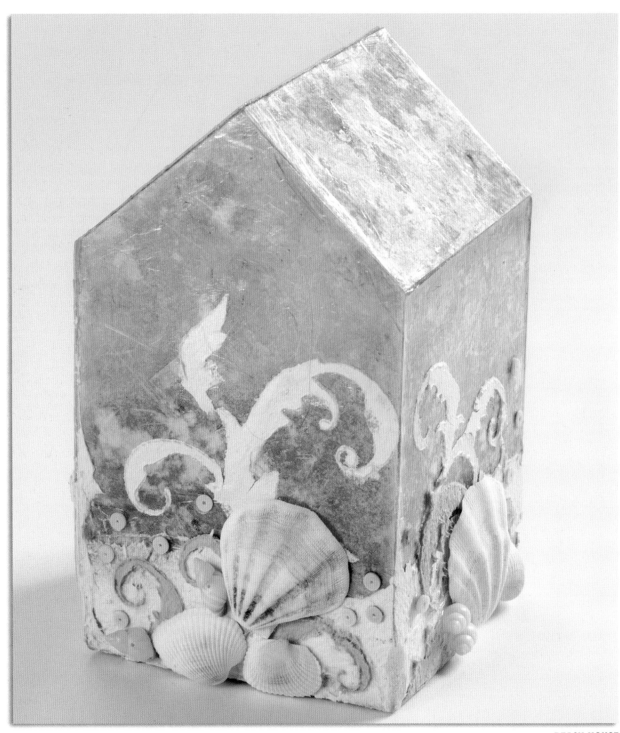

BEACH HOUSE
DARLENE OLIVIA MCELROY
(Mica, shells, stencils, beads.)

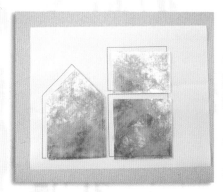

1 Using the template, cut out two of each shape from mica.

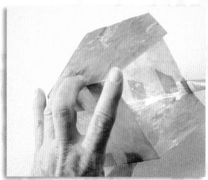

2 Tape the side panels together and apply soft gel gloss along all seams.

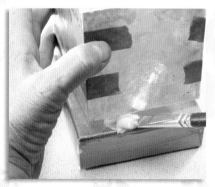

3 Use a 4" × 4" (10cm × 10cm) box or a box canvas for a base and glue the house onto the base. Allow all gel and glue to dry. Remove the tape.

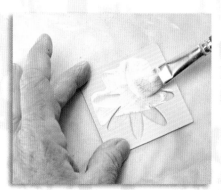

4 Stencil fiber paste onto a sheet of polypropylene plastic and let dry.

5 Peel the stenciled fiber paste elements off the plastic and glue them onto the house.

6 Glue on found objects to complete your piece as desired.

TIPS, TROUBLESHOOTING AND MORE IDEAS

» Add lights inside your house. You may need to drill or cut a hole into the mica or the base to accommodate a cord. This should be done before assembly of the house structure.

» Create a diorama for your house that tells a story.

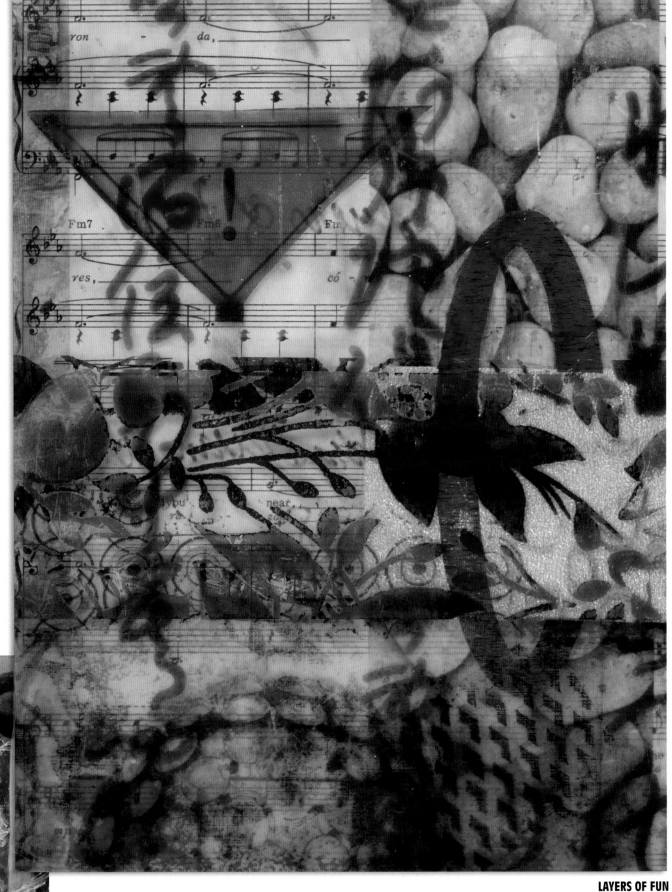

LAYERS OF FUN
SANDRA DURAN WILSON
(You can apply waterslide decals, dry gel or paint transfers and transparencies to Plexi. And you can apply them all to the same piece of Plexi, if you'd like. You have two sides to work with, and this technique can give your art the appearance of great depth. Gel transfers, Papilio waterslide transfers, collage papers from a music score adhered to both sides of a Plexi piece using spray adhesive.)

Visit artistsnetwork.com/alternative-surfaces for bonus demonstrations, tips, ideas and more!

5 CAST ACRYLIC

Lexan and Plexiglas are trademark names for cast acrylic, and cast acrylic is frequently generically referred to as Plexi (which is something I will do throughout this chapter). You can purchase many different grades, thicknesses and sizes of Plexi. It even comes in white and opaque, but I prefer it luminous and transparent. It can be painted on one side or both sides and layered to create paintings with great depth. Think of the fun you can have painting with regular and interference paints, adding gold leaf and adhering dimensional objects to Plexi. In addition to additive techniques, you can do subtractive work on Plexi. And I love all the great ways Plexi can be mounted and displayed.

MATERIALS FEATURED IN THIS CHAPTER:

- » acrylic paint
- » cast acrylic (such as Plexiglas or Lexan)
- » collage papers or sheet music
- » Dremel or etching tool
- » drill
- » ephemera
- » heavy gel
- » masking tape
- » materials for mounting
- » paintbrushes
- » pencil
- » Plexi scoring tool
- » punchinella
- » rubber stamps
- » rubbing alcohol or Plexi cleaner
- » sandpaper
- » soft cloth
- » spray adhesive
- » spray bottle filled with water
- » spray webbing
- » StazOn ink
- » stencils
- » straightedge
- » waterslide, dry gel or paint transfers or transparencies

Preparing Your Surface
With a soft, damp cloth, gently clean the surface of the Plexi to remove any dust or debris. You can use rubbing alcohol or special Plexi cleaners if desired or necessary.

Cutting
Use a tool for scoring Plexi and run it through the same groove multiple times to create a deep score line. Place the score line against a sharp edge and snap to break the Plexi.

Drilling
If you need to drill a large hole, start with a smaller drill bit and work your way up to a larger hole. Take your time and be patient when drilling Plexi.

Painting & Collage

You can add many surface treatments to Plexi, including alcohol resist, scribing and stamping. Because Plexi is a nonporous surface, paint will take longer to dry, but the effect will be rich. Don't be afraid to layer several techniques. Give your work adequate cure time. You might try working on several pieces at once.

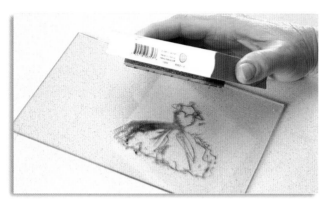

1 Stamp an image onto one side of the Plexi. Use StazOn stamping ink for best results. Allow the ink to dry completely or heat set it. If you heat set, be very careful because the heat can warp the Plexi.

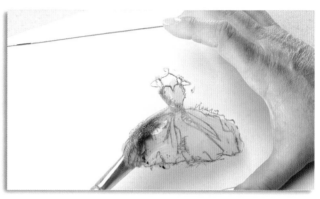

2 Paint in the image on the opposite side of the Plexi to maintain the detail of the stamped image. Allow the paint to dry completely.

3 Add a little bit of paint to the front side of the Plexi. Mist with water to thin the paint.

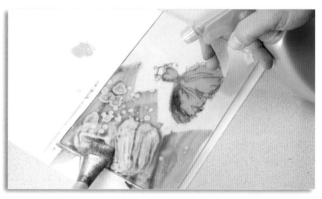

4 Blend the paint. Mist again if necessary to keep the paint pliable. When you are satisfied with your painting, allow the paint to dry completely.

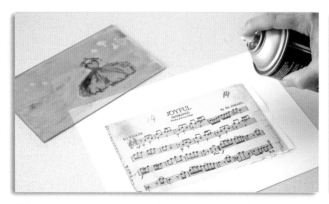

5 Spray adhesive onto sheet music or other paper.

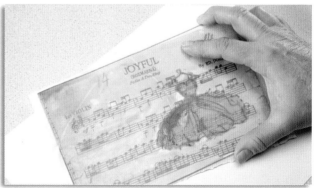

6 Press the paper onto the back of the painted Plexi.

34

7 Mix acrylic paint with a bit of heavy gel.

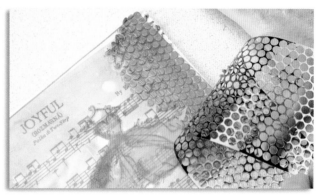

8 Add texture to the front of the Plexi by stenciling the gel through a piece of punchinella or other stencil.

TIPS, TROUBLESHOOTING AND MORE IDEAS

There are companies on the Web that can digitally print on Plexiglas. If you opt to give them a try, make sure you know whether they are printing a white or clear coat on the back of your Plexi because the two will have very different looks.

Encasing & Laminating

Sandwich thin objects between two layers of Plexiglas. You can either put the layers in a frame or use hanging brackets to mount the final piece.

For the insets in this piece, I drilled holes in the Plexi and attached wood discs using small two-pronged brackets.

KEY TO THE UNIVERSE
SANDRA DURAN WILSON

Etching/Sandblasting

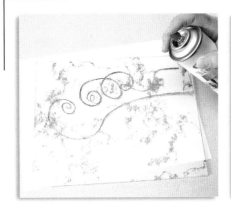

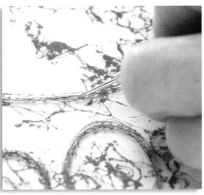

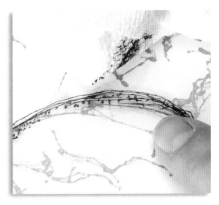

1 Draw a simple design on one side of a piece of Plexi. Flip it over and add texture to the opposite side of the Plexi with spray webbing.

2 Flip the Plexi back to the side you drew on. This is a great time to use your Dremel tool to write or etch designs on your surface. Work slowly and with the appropriate Dremel point.

3 Stain the etching with paint or ink.

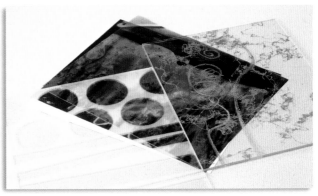

4 Cover various areas on another piece of Plexi with a mask. (Masking tape is an easy-to-use and easily accessible masking material.) Sand a design into the surface with sandpaper. Remove the tape.

5 Paint on or apply a waterslide decal to a third piece of Plexi.

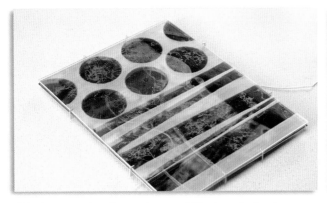

6 Arrange the three pieces of Plexi as desired.

7 A Uniframe is a clip frame that holds all the pieces together. There are several variations to be found at frame shops and art stores. Some tighten the clamps with string and springs. Follow the directions that come with your Uniframe.

DEEP SPACE
SANDRA DURAN WILSON
*(This piece is made up of three different
pieces of Plexi. You can create different looks
by rearranging the order of the pieces.)*

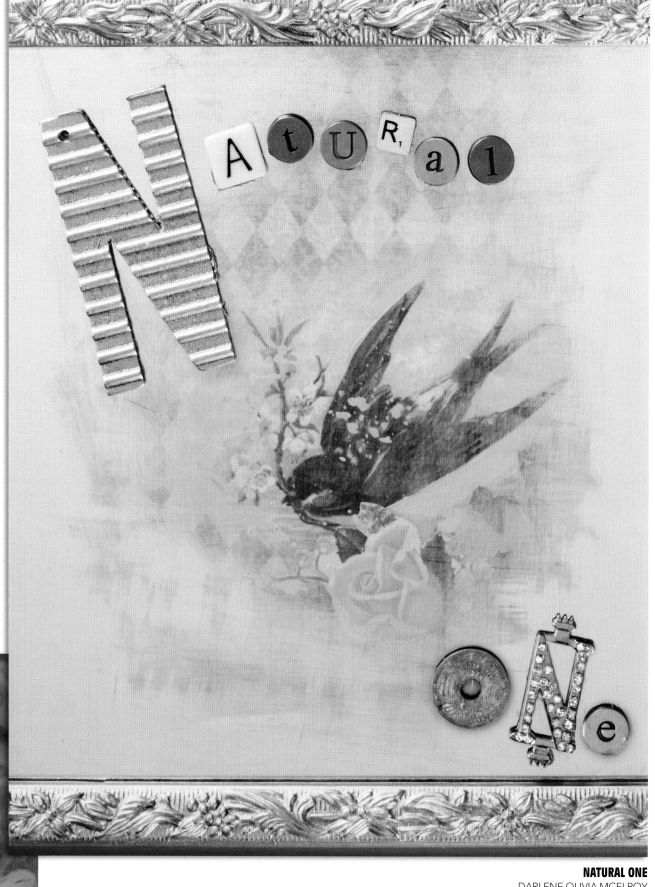

NATURAL ONE
DARLENE OLIVIA MCELROY
(Glass with Krylon Looking Glass spray; collaged on front and back.)

Visit artistsnetwork.com/alternative-surfaces for bonus demonstrations, tips, ideas and more!

6 GLASS, MIRRORS & FAUX MIRRORS

Glass comes in a rainbow of colors, with and without texture, and also in powder form. It can be cut, cast, painted or silkscreened, and it is more durable than Plexiglas. It radiates and communicates mood and tone. For example, think of the warm glow of the stained glass windows in a house of worship.

A mirror starts as clear or smoked glass that is coated on its reverse side with silver or aluminum in a special chemical process. That coating can be stripped back, and a patina or image transfer can be added. Doing so results in a very interesting illusion of depth brought on by the mirror's still reflective quality. And now you can even create your own faux mirror with a piece of glass and Looking Glass spray from Krylon.

You can work on both the front and back sides of both glass and mirror glass, and that can add a lot of visual interest.

MATERIALS FEATURED IN THIS CHAPTER:

- » acrylic paint
- » base for sculpture (grooved)
- » E6000 adhesive
- » embellishments
- » glass cleaner
- » glass grinder, file or sandpaper
- » glass or Plexiglas
- » Krylon Looking Glass spray paint
- » paintbrushes
- » paper towels
- » picture frame
- » polyurethane spray
- » rag or cloth
- » spray adhesive
- » spray bottle filled with rubbing alcohol
- » scribing tool
- » toner image or photograph
- » waterslide decals

Preparing Your Surface

Clean your surface with glass cleaner to remove any grease or fingerprints. If the edges of your glass or mirror are rough, smooth the edges with a glass grinder, file or sandpaper.

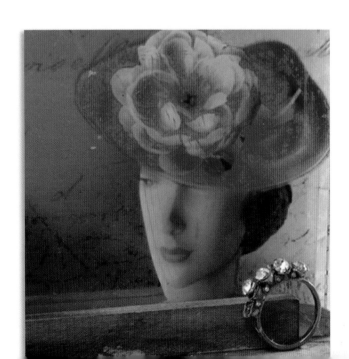

Creating a Faux Mirror Collage

Krylon's Looking Glass spray paint creates a mirror finish. It can be sprayed on glass or Plexiglas. (You'll get a more authentic look with glass.) While the paint is still wet, you can blot it with a rag, spray alcohol on it or scribe into it for a unique aged look.

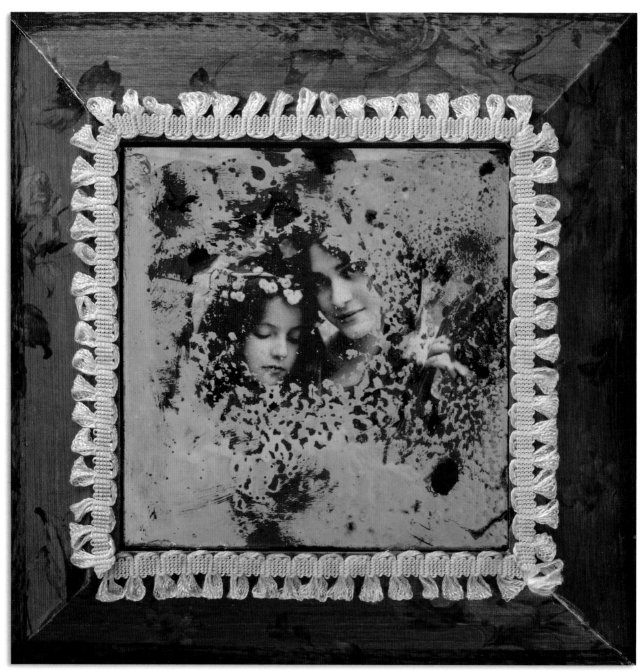

PRIZED POSSESSION
DARLENE OLIVIA MCELROY
*(Glass with Looking Glass spray, wood frame
with image transfer objects, collage elements.)*

1 Spray a piece of glass with Looking Glass spray paint. Be sure to do this in a well-ventilated area. While the paint is still wet, spray a bit of rubbing alcohol into it to create a speckled surface.

2 After the paint has dried, soak a paper towel with more rubbing alcohol and use it to remove some of the paint, creating clear areas through which your collage elements can show.

3 Paint some areas with Burnt Umber or black paint and let the paint dry.

4 Spray adhesive on the face of your image. Press the image to the back of the faux mirror glass.

TIPS, TROUBLESHOOTING AND MORE IDEAS

If your faux mirror is not as reflective as you'd like, you can apply additional coats of Krylon's Looking Glass spray paint.

5 Mount the glass in a frame and embellish as desired.

Layered Glass Sculpture

We generally think of glass as a flat medium or perhaps cast in shapes. But it can also be used to make a wonderful dimensional sculpture.

 With all sculpture, it is important to figure out how it will be mounted before starting your piece.

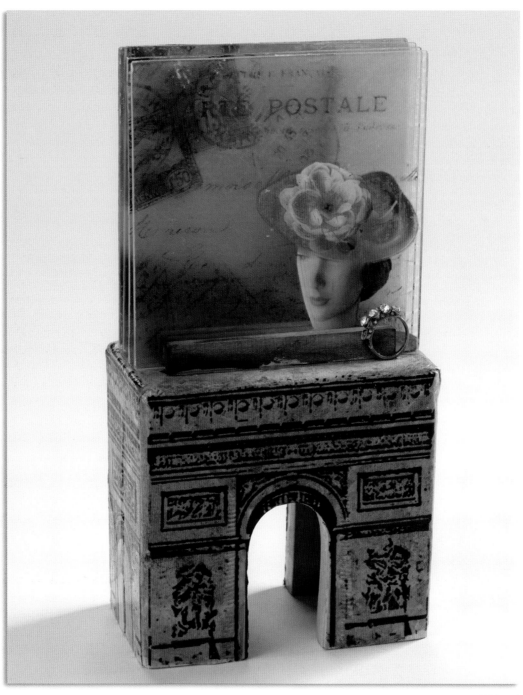

PARIS DAYS
DARLENE OLIVIA MCELROY
(Glass, transfers, wood object, small ring.)

42

1 Assemble your elements.

2 Apply waterslide decals to the back of the glass pieces.

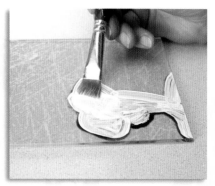

3 Apply paint as desired—you may want to add highlights or make some areas opaque (as shown here).

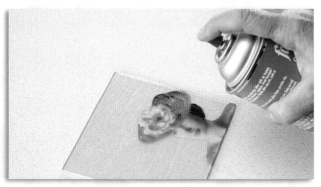

4 Spray each piece of glass with a polyurethane spray if you think they will be handled often.

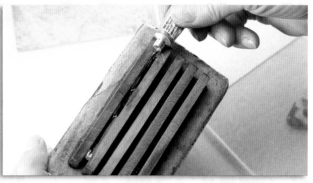

5 Apply glue to grooves in the sculpture's base if you want the glass permanently placed in position. If you want the glass pieces to be interchangeable, do not apply glue.

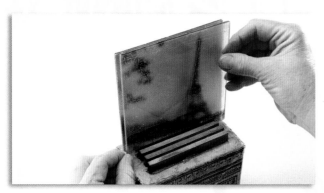

6 Put each piece of glass in a groove. (Clean the surface of each piece of glass if necessary.)

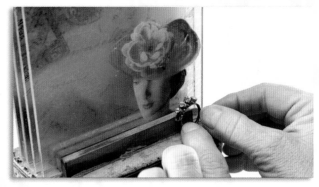

7 Glue a dimensional object to the sculpture's base in front of the layered glass.

TIPS, TROUBLESHOOTING AND MORE IDEAS

» Have the glass cutter smooth the edges so the glass won't cut your hands.
» Make sure you have a stable base for your piece.

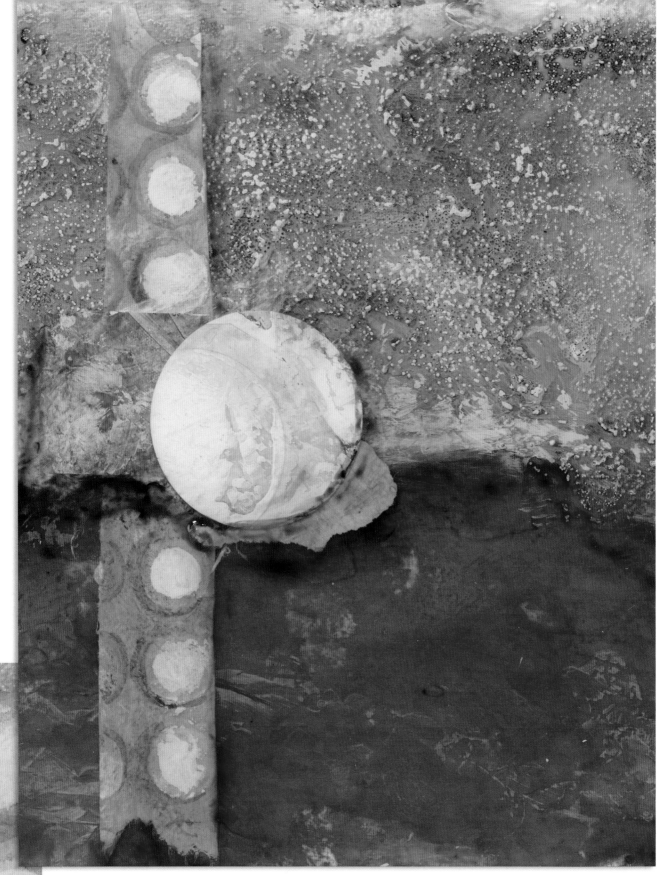

EARTH SINGS
SANDRA DURAN WILSON
*(This is an acrylic painting that has a
resin pour. Collage elements were
added in a second pour. This increases
the depth and accentuates the texture.)*

Visit artistsnetwork.com/alternative-surfaces for bonus demonstrations, tips, ideas and more!

7 RESIN

Two-part resin is not what it used to be. I remember strong fumes that could linger for months. The fumes are gone today, but you still need to be cautious and follow all manufacturer directions. Resin is currently a popular finish to apply over paintings and photographs, but you can do so many other things with it: cast it into jewelry or sculpture, paint with it, make books and collages, and even embed objects in it. A resin surface can also be altered from a gloss to a matte finish. I have even made thin sheets of resins (like skins) and adhered them to acrylic paintings. And, of course, you can apply transfers to resin, and you can paint on it and with it.

MATERIALS FEATURED IN THIS CHAPTER:

- » acrylic and/or oil paints
- » acrylic box frame
- » butane or propane torch or heat gun
- » collage papers (such as vintage book pages) or fabric
- » craft/stir sticks
- » foam brushes
- » gloves
- » interference paints
- » large, clean box
- » masking tape
- » materials for embedding (such as micro beads)
- » mixing cups
- » molds for casting (silicone candy and jewelry molds work well) paintbrushes
- » paper embellishments
- » plastic tarp or sheet
- » powdered pigments
- » respirator mask
- » steel wool
- » substrate: panel (recommended) or small stretched canvas
- » two-part resin (such as EnviroTex)

Resin Basics

There are many brands of resin, intended either for pouring or casting. I use EnviroTex resin. EnviroTex makes a formula that contains UV inhibitors. Read all the manufacturer's directions, twice even. If you do not use equal portions of both parts and if you do not mix it thoroughly, the resin will never cure.

When you are mixing small amounts of resin, the proportions are especially important. It is also very important to protect your skin by wearing gloves. If you do get resin on your hands, wash with soap and water as soon as possible and see the manufacturer's safety precautions.

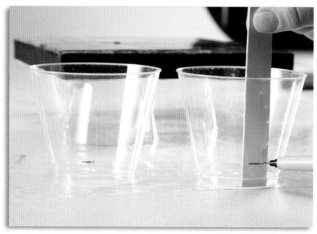

Precise measuring and pouring is critical. You can buy cups with measurements marked on them, but they cannot be reused. You can also mark disposable cups for easy measuring.

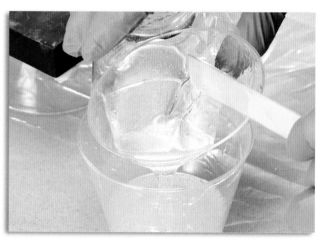

Combine the components according to the directions for your specific brand of resin.

Carefully and thoroughly mix the resin components. (Use a two-cup mixing method as seen in package directions.)

TIPS, TROUBLESHOOTING AND MORE IDEAS

» Make sure the area you are working in is clean and well ventilated.
» Gather all of your supplies before beginning and cover your work area with a plastic tarp or sheet.

Painting & Layering

You can paint on top of resin with most paints (both acrylic and oil will work with resin). I find it fun to paint or collage on top of a resin pour and then do another pour on top of that. You get incredible depth. Keep in mind that resin is heavy, so if you are working large, take the potential weight into account. I would suggest working only on a panel substrate. If you work large and do multiple pours on a stretched canvas, the weight could be too much for the canvas.

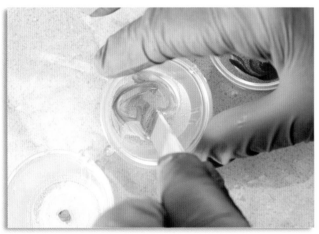

You can purchase special tints made for resins, but I've found that mixing a small amount of acrylic or oil paint into resin will yield good color as well. Powder pigments will also work. Wear a mask when working with powders, and always wear a mask when working with resin.

In these examples, I tinted smaller amounts of resin with interference paints and painted over a dark background. I used craft sticks to paint with the resin. The resin suspends the paint and creates a great finish.

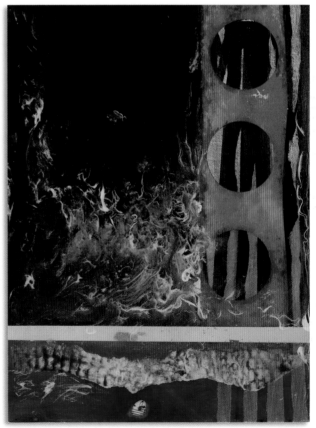

TRANSFORMATION
SANDRA DURAN WILSON

Resin Pour

Pouring resin over a finished painting, photograph or drawing gives the work greater depth. I suggest that you begin your experimentation with a smaller painting, no larger than about 8" × 10" (20cm × 25cm). Save yourself aggravation and don't start with a huge piece.

Also, if you are pouring over a stretched canvas, you will need to put some sort of support under the canvas or the resin will pool.

Tape the bottom edges of the piece as a barrier to the resin. Place the piece right side up, elevated over a piece of plastic (to catch any drips). I rested my piece on an inverted plastic cup. Ensure that the surface you are working on is level.

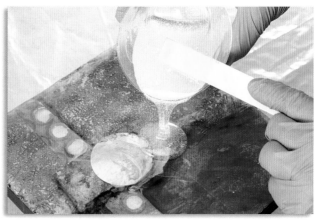

Slowly pour resin over the piece.

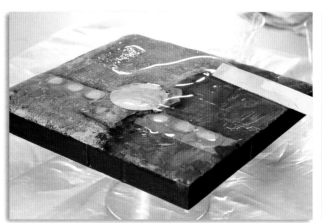

Carefully spread the resin with a paint stirrer or craft stick. An old plastic key card works well also.

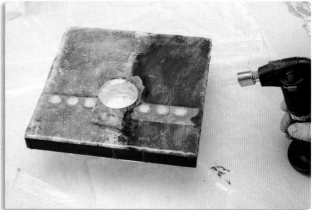

Once your resin is poured, you have about 10 minutes to eliminate any bubbles. It is not heat but carbon dioxide that breaks the bubbles. You can use a heat gun, but I don't recommend this because it will blow dust around and into your resin. I like to use a propane torch, but you can also use a small kitchen (butane) torch. Sweep the flame over (not into) the surface, being careful not to overheat or hold the flame too long in one spot. Once the bubbles are gone, carefully place a clean box or container over the painting to keep dust particles off. Your work will dry in about 8 hours, but more time is needed for a full cure. Drying and curing time depends on temperature and humidity.

Embedding

You can sprinkle beads or objects into your resin once it has been poured as long as it is still workable. In this demo I am using an acrylic box frame and pouring layers of resin interspersed with materials embedded into the different layers. I did not worry about bubbles with this technique and did not use a torch to eliminate them.

Add paint and beads or other materials to a layer of poured resin. Let the resin dry.

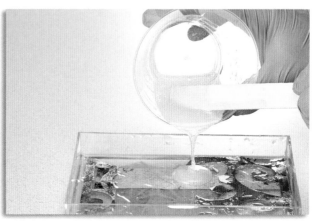

Slowly pour a new layer of resin. Repeat previous steps, adding beads or other materials as desired.

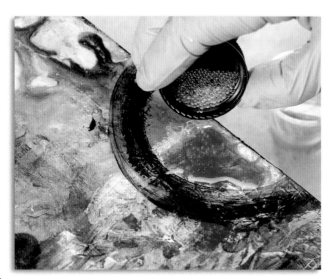

You can also add a bit of texture or visual interest to a piece by adding beads or other materials and using resin as a glue of sorts to add texture on the surface.

Resin Collage Paper

Mix resin and use a foam brush to coat paper or fabric with resin. Turn the paper over and coat the other side as well. Some papers will become transparent, and others will become only slightly translucent.

Book pages are fun to use because the pages become transparent and the text from one side will bleed into the other side.

1 Lay a plastic trash bag or plastic sheet on your work surface. Mix resin and spread it on the plastic.

2 Lay papers (or fabric) in the resin and use a foam brush to coat the papers with more resin.

3 Lay in embellishments as desired.

4 Layer or paint with tinted resin if desired.

TIPS, TROUBLESHOOTING AND MORE IDEAS

» You can do gel transfers onto resin, and waterslide decals work well, too. Simply apply a transfer or decal to cured resin and then layer on more resin.

» You can create multilayered collages with resin and paper.

» When your resin papers are cured, they will be stiff.

5 Allow the resin to cure completely and then peel the resin paper off the plastic tarp.

Resin Casting

You can find lots of great mold-making tutorials online if you are interested in casting custom shapes and pieces. For the sake of simplicity though, I recommend beginning with a silicone candy or jewelry mold. Tint the resin if you'd like, or embed beads, papers or whatever objects you have at hand. Don't use the torch with this method. Try exhaling on the cast to eliminate bubbles, but don't inhale over the resin.

Final Finish

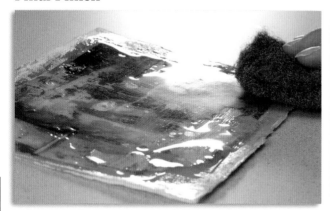

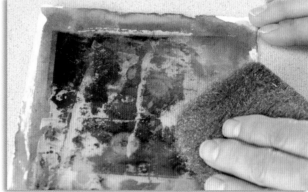

If you don't like the shiny, smooth-as-glass look, you can use steel wool to create a nice satin or even a matte glow.

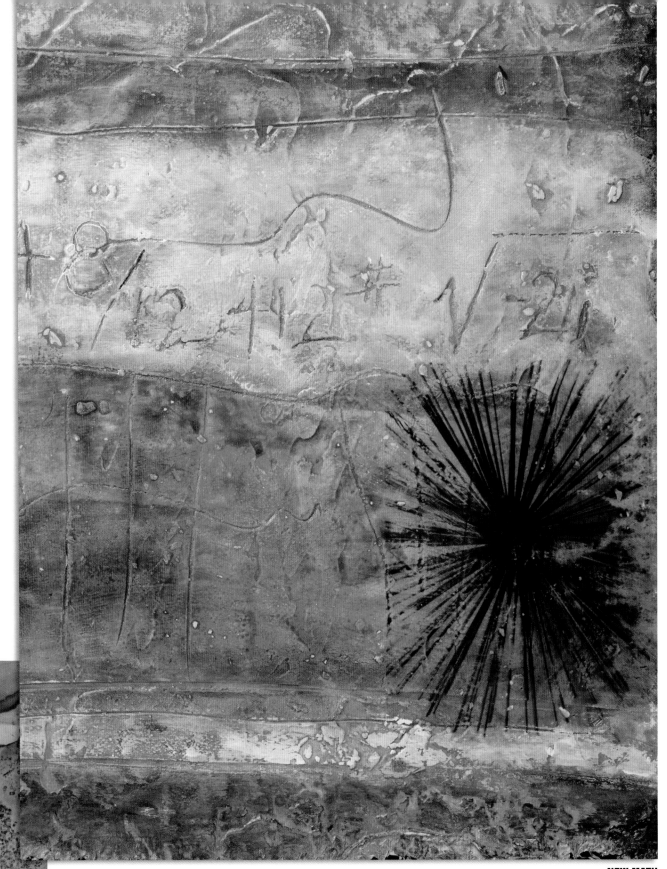

NEW MATH
SANDRA DURAN WILSON
*(Unsanded grout on canvas with scratching,
scribing, sanding and transfers.)*

Visit artistsnetwork.com/alternative-surfaces for bonus demonstrations, tips, ideas and more!

8 CEMENT, MORTAR & UNSANDED GROUT

Portland cement is an ingredient in concrete, which is a mixture of cement, sand and aggregate. Cement usually means heavy, but you'll learn how to make it light(er) weight; try working with mortar or unsanded grout, which has cement as an ingredient. Working with mortar or grout is very similar to working with plaster, but the mortar will be harder when dry.

MATERIALS FEATURED IN THIS CHAPTER:

- » acrylic medium or resin
- » acrylic paints and watercolors
- » black foam core
- » butane or propane torch
- » canvas or other heavyweight fabric

- » ceramic tiles
- » course pumice gel
- » craft paper
- » ephemera for embedding
- » latex house paint
- » Liquid Nails adhesive

- » nonflammable surface
- » paintbrush
- » palette knife
- » plastic tarp or sheet
- » Prismacolor pencils, charcoal or oil pastels

- » rub-on transfers
- » sandpaper
- » scribing tools
- » shellac
- » spray bottle filled with water
- » unprimed canvas

- » unsanded grout, premixed adhesive grout
- » waterslide decal
- » wood frame
- » wood panel

Unsanded Grout on Raw Canvas

Use unprimed canvas. Place the canvas on a plastic sheet or tarp. Mix the unsanded grout according to the manufacturer's directions.

Mist the canvas with water and rub the water into the canvas. Spread the grout onto the canvas, rubbing hard to ensure adhesion.

You can scribe into the surface of the wet grout or drop more grout to build texture. Let the grout dry completely.

When dry, flip the canvas over and apply grout for added stability. Let dry. Draw or even embed papers or elements into the grout. Here I am embedding lace paper.

Cover the grout-covered canvas with craft paper and mist with water several times throughout the day. Let the grout cure for at least a day. Ideally, the grout should cure for at least three days.

TIPS, TROUBLESHOOTING AND MORE IDEAS

» **Paint on Grout**—Craft acrylic paints work best; try a watered-down artist's acrylic paint or even house paint. You don't want a thick plastic layer over the grout; you want the watered-down paint to soak into the grout.
» **Drawing**—This is a wonderful surface to draw on with Prismacolor pencils, charcoal and oil pastels.
» **Cracks**—The dried grout can develop wonderful cracks when you pick up the canvas and bend it. Make the cracks an element of your art.
» **Mounting**—Use Liquid Nails to adhere the grouted canvas to a rigid surface. To make your piece of art even more lightweight, attach the canvas to foam core and then attach it to a wood frame.

Unsanded Grout on Glazed Ceramic Tile

Apply grout to a glazed ceramic tile.

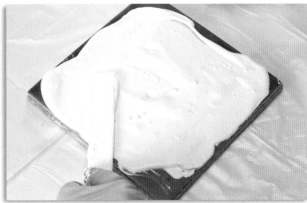

While the grout is wet, you can add texture. Or you can let the grout spread and establish its own texture. Let the grout dry.

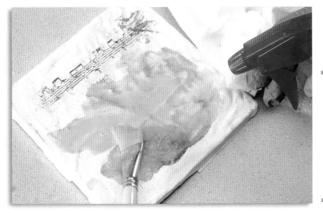

You can apply any variety of surface techniques to the dried grout. Here I have applied a rub-on transfer of sheet music and an acrylic paint that has been thinned with water.

TIPS, TROUBLESHOOTING AND MORE IDEAS

» Make several grout covered tiles and adhere them to a wood panel with grout between them. Try a sanded or colored grout to make the tiles pop.
» You can use an acrylic medium or resin on top to seal, if desired.

Grout on Canvas

Grout on Canvas
After unsanded grout has dried, you can bend and crumble the canvas to create cracks.

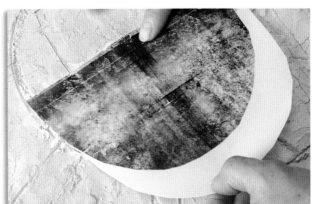

Transfer
You can use a waterslide decal on the surface. Let it dry overnight and then sand slightly to integrate the transfer and reveal part of the grout.

Shellac and Paint Burn on Cement

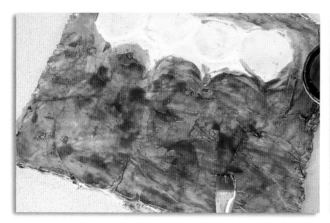

1 Apply shellac to your cement surface.

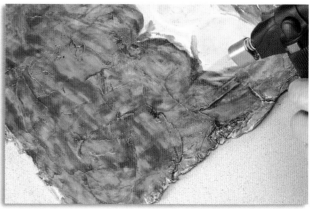

2 While the shellac is still wet, use a torch to ignite the shellac. Please do this outside and make sure the cement surface is placed on a nonflammable surface.

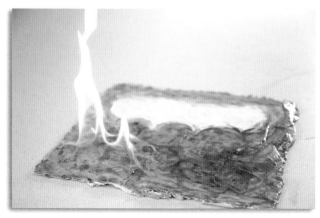

3 Let the shellac burn. The chemicals will self-extinguish.

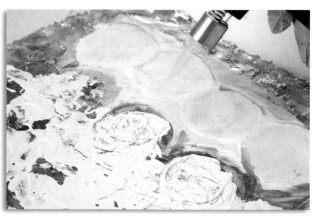

4 Next apply latex house paint and use your torch to bubble and burn the paint.

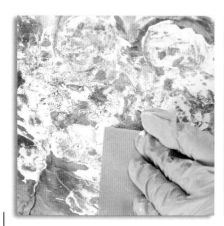

5 Let cool and then sand for an even more distressed look.

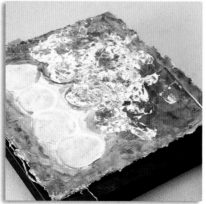

6 Cut a piece of black foam core to size for use as a mounting board.

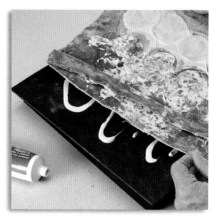

7 Use Liquid Nails to adhere cemented canvas to foam core.

Faux Cement

Premixed adhesive grout (which can be purchased from a big-box home store or a hardware store) makes a good stand-in for cement. I think of it as a faux cement.

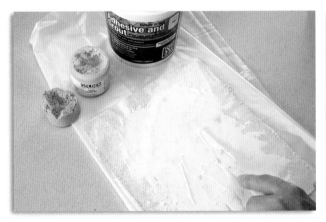

Apply a thin layer of faux cement to raw canvas in the same manner demonstrated in the unsanded grout demonstration. Allow to dry completely.

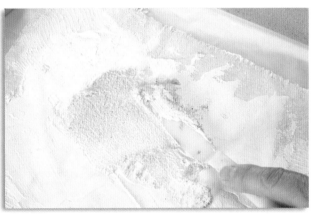

Apply a second thin layer of faux cement. While it is still wet, apply some coarse pumice gel and blend it into the faux cement. Let dry.

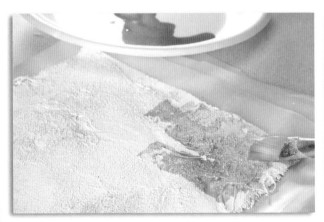

After the cement and pumice gel have dried, paint as desired with a thinned acrylic paint or watercolor.

This is also a wonderful surface to draw on with Prismacolor pencils, charcoal or oil pastels.

TIPS, TROUBLESHOOTING AND MORE IDEAS

You can mount this canvas on a panel, or instead of working on a piece of raw canvas, experiment with working on a stretched canvas. You will need to insert something behind the stretched canvas to give support to the canvas while working on it.

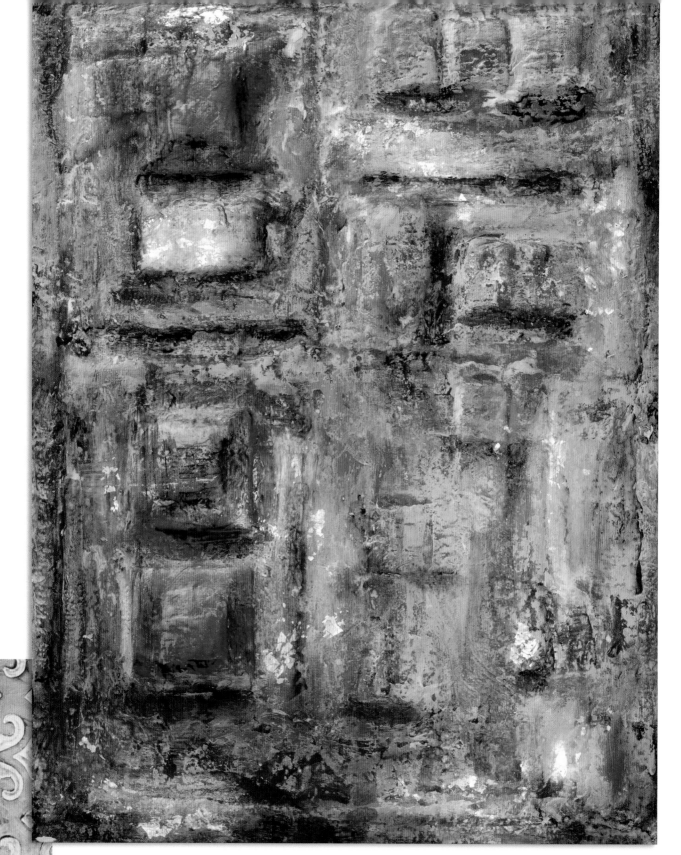

HISTORY IN THE MAKING
SANDRA DURAN WILSON
(Layers of plaster gauze and Venetian plaster applied over
cardboard, painted and distressed with gold leaf added.)

Visit artistsnetwork.com/alternative-surfaces for bonus demonstrations, tips, ideas and more!

9 PLASTER OF PARIS, VENETIAN PLASTER & PLASTER GAUZE

Plaster is my favorite material to paint on. It is smooth and highly absorbent, and it takes on a rich eggshell quality that cannot be achieved with other materials. The surface may be sanded or burnished to a beautiful smooth surface, but I personally like a surface that reveals the gentle ridges of the palette knife. It is like playing with clay and earth without having to fire it. There are so many ways to work with plaster—this is just the beginning.

MATERIALS FEATURED IN THIS CHAPTER:

- » acrylic or watercolor paints
- » bowl of water
- » cardboard
- » deli or watercolor paper
- » gloves
- » glue (such as PVA)
- » gold leaf
- » gold leaf sealer or MSA varnish
- » hardware for hanging
- » masking tape
- » measuring cups
- » objects for embedding
- » paintbrush
- » palette knife
- » plaster of Paris, plaster gauze, Venetian plaster
- » plastic tarp or sheet
- » plastic tub
- » Prismacolor pencils, charcoal and oil pastels
- » sandpaper
- » spray bottle filled with rubbing alcohol
- » stir stick
- » substrates, such as plywood or cradled wood panels
- » textured paper, plates or stencils

Want more?
Visit artistsnetwork.com/alternative-surfaces for bonus demonstrations:
Working with Venetian Plaster and
Working with Joint Compound.

Plaster of Paris

Plaster of Paris is purchased in powder form and mixed with water to create a chemical reaction that causes the plaster to harden. The process may be accelerated by using warm water, but then the working time is shortened. There are three stages to working with plaster. During the initial stage, the plaster is mixed with water and is pourable or spreadable. This may be from 5 to 20 minutes, depending on temperature, humidity, etc. The second stage is when the plaster is set and hard but still holds moisture, and the third is when the plaster has cured. I typically wait 24 hours for the plaster to cure before painting on it.

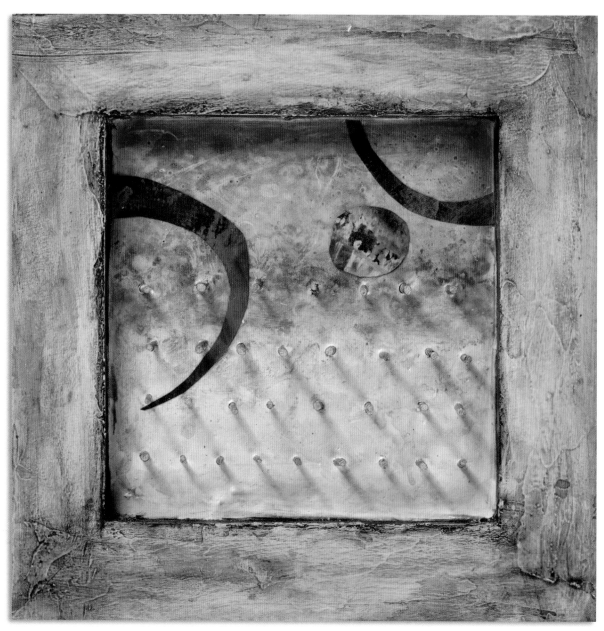

TIME KEEPER
SANDRA DURAN WILSON
(Poured plaster of Paris, Venetian plaster frame, acrylic paint and collage.)

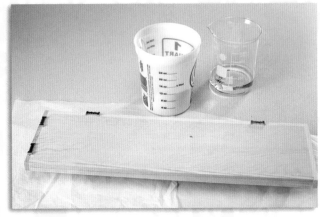

Preparing Your Surface

Use a wood substrate like plywood or a cradled wood panel. If you work on wood that is not braced or cradled, the wood will warp and your plaster may crack off.

You will need a plastic tub for mixing the plaster, a stir stick, masking tape if you need to create an edge and measuring cups.

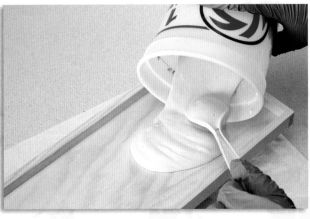

Mounting Ideas

Use a cradled wood panel backwards—fill it with plaster to create an easy frame. Attach any hardware for hanging prior to pouring.

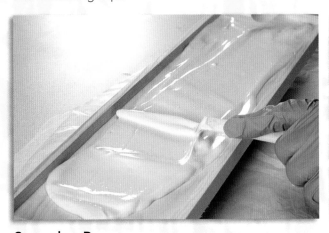

Spread or Pour

Plaster of Paris has the advantage of being able to be poured or applied in a thick layer. Cracking is unlikely.

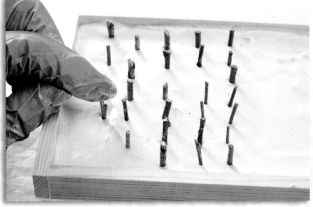

Embedding

Plaster is also great for embedding objects. Here I am embedding birch branches into poured plaster.

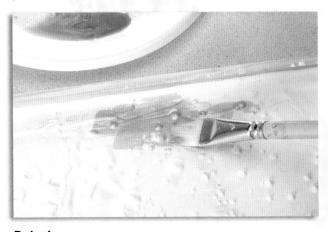

Painting

Acrylic craft paints work best, but watered-down artist's acrylics and watercolors are also viable options. You want to water down your paint because you want it to soak into the plaster. A thick, plasticky layer of acrylic will never soak into the plaster.

TIPS, TROUBLESHOOTING AND MORE IDEAS

» Once the water has been added to the plaster, the process cannot be reversed, so you'll need to have everything prepared.
» This is a wonderful surface to draw on with Prismacolor pencils, charcoal and oil pastels.

Plaster Gauze

Plaster gauze can be applied over cardboard to create dimensional work. Use plywood and attach your hanger to the back side (preferably before you apply the plaster gauze).

This process gets messy, so I recommend putting a plastic sheet or tarp over your work area and wearing gloves.

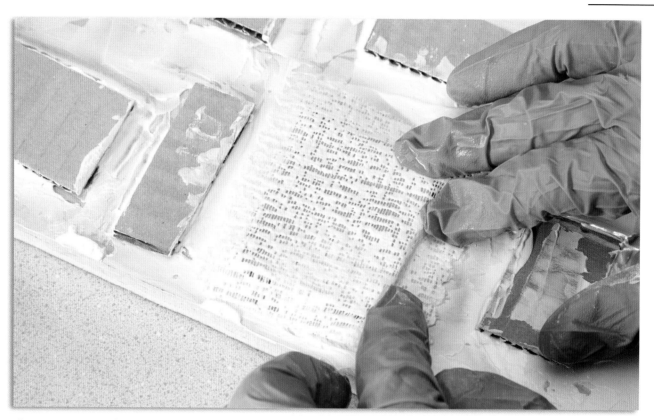

Getting Started
Apply a thin coat of either Venetian plaster or plaster of Paris to a wood panel. Let the plaster dry completely.

Add Dimension
Build up the surface with cardboard; use glue to attach the cardboard to the wood panel.

Apply Gauze
Cut gauze to the desired size. (If your project will require a lot of smaller pieces of gauze, you may want to cut them all ahead of time.) Quickly dip a piece of gauze into a bowl of water, press out the extra water with your fingers and apply the gauze to your surface. Rub the gauze into the surface to ensure good adhesion. Keep building up your surface, overlapping the gauze pieces. Let all of the gauze dry completely, at least 24 to 36 hours, before painting.

Painting
Paint, seal and apply additional layers of plaster as desired (I used Venetian plaster). Sand the plaster and gauze back in areas to give your piece a distressed look.

Bling
Spritz a small amount of alcohol onto the surface of your dried plaster gauze piece. Rub the alcohol into the surface until it becomes tacky. Apply gold leaf. Rub the gold leaf down to ensure good adhesion, and when finished, spray or paint on a gold leaf sealer or MSA varnish.

Plaster Papers

Use deli papers or watercolor paper to create great collage papers with plaster. Please note that the plaster must be applied very thin. You may apply more than one coat, but if the plaster is too thick, it will not adhere to the paper.

Texture

Venetian plaster works best for this technique. Place a sheet of deli paper over a textured paper or stencil, and drag the plaster over the top of the deli paper. Let the plaster dry and then paint both sides of the paper. ... e paint dry and use the paper as a collage paper.

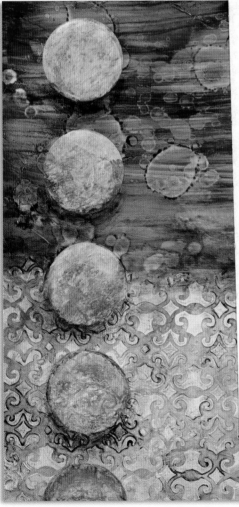

rs with alcohol
ound. The
r that had
ry thin layer.)

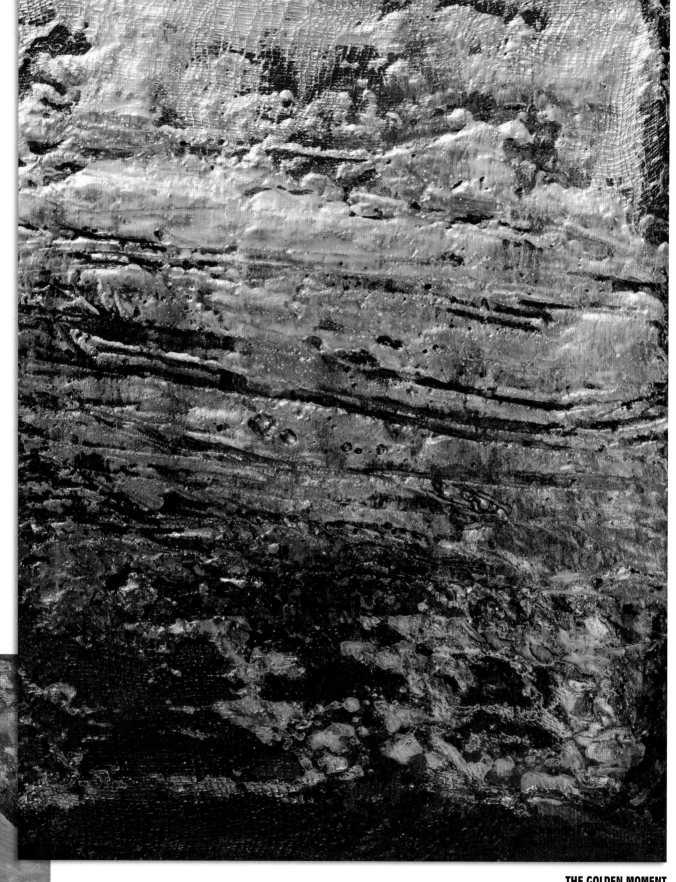

THE GOLDEN MOMENT
DARLENE OLIVIA MCELROY
(Poured clay on panel.)

Visit artistsnetwork.com/alternative-surfaces for bonus demonstrations, tips, ideas and more!

10 CLAY, PAPERCLAY & CLAY MONOPRINTS

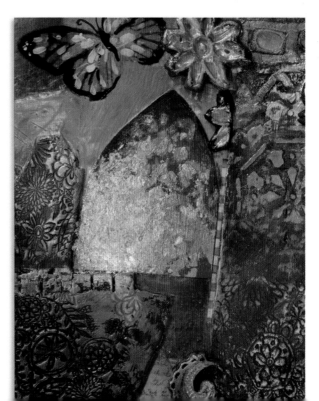

Clay products today come in all shapes and sizes. You can cast, mold, emboss, sculpt, carve and paint these surfaces. They can be your substrate or an added dimension to another piece of art. While some clay needs to be baked or fired in a kiln, we are going to work with clay that is self-hardening. It takes texture beautifully, and working on clay as a substrate to create monoprints is so spontaneous and easy that you just may get addicted to it.

MATERIALS FEATURED IN THIS CHAPTER:

- » acrylic paints
- » brayer
- » butcher paper
- » ceramic clay, powdered air-drying clay, resin clay and Paperclay
- » clay/carving tools
- » cup or mixing bowl
- » epoxy or silicone glue
- » found and collected objects, decorative elements
- » hardware for hanging
- » object for creating a mold
- » paintbrush
- » paper (watercolor paper works well)
- » paper towels
- » plastic squeeze bottle
- » plastic tarp or sheet
- » plastic wrap
- » plastic zip-top bag
- » rubber stamps or texture plates
- » rusting solution, metal leaf
- » semi-rough surface
- » substrate: wood panel or stretched canvas
- » two-part molding compound or liquid latex
- » water
- » white glue
- » wire

Preparing Your Surface

Make sure there is no dust on the surface by wiping with a damp paper towel and then let it dry. If doing a clay monoprint, work on butcher paper or a plastic sheet to protect your work surface.

Clay Monoprints

This takes me back to kindergarten because this is so much fun! It allows you to create a lot of abstracts and backgrounds spontaneously. I buy clay at the local ceramics store by the 20-lb. (9kg) bag, which lasts me quite a long time. Play with different paint viscosities for different looks.

1 Cut off a piece of clay and roll it flat on a piece of plastic or butcher paper.

2 Press stamps and textures into the clay. Make marks in the clay with a knife or clay tools.

3 Paint the clay or stamp into it with a painted stamp.

4 When you are pleased with your design, lay a piece of paper on top of the clay. Brayer the back of the paper.

5 Lift the paper off the clay.

6 You can often create a second print from the clay before adding more paint.

TIPS, TROUBLESHOOTING AND MORE IDEAS

» You can continue using the clay by adding more texture and paint or by turning the clay over and starting fresh.
» When finished, roll the clay into a ball and put it in a well-sealed plastic bag with a little water for later use.
» This technique works well using both fresh, moist clay and clay that is leather hard. If your clay is more than leather hard, it will be impossible to stamp texture into it, and it may break when brayering the design onto the paper.
» The paint will stain a wood rolling pin.
» Clean clay by brayering a paper towel on top to pick up leftover paint.

Pouring Clay

Pour into folds, pour lines through a bottle, or pour and scrape or scratch. Working with clay is a wonderfully physical art form. Using a powdered, air-drying clay is an easy way to do this, and you can mix as much as you need for your project while saving the rest for another day without having to worry about the clay drying out.

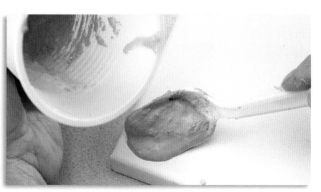

1 Mix powdered clay with 50 percent white glue and a little water.

2 Pour the clay onto your surface and spread it around to create folds.

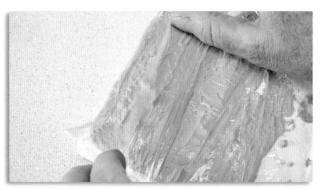

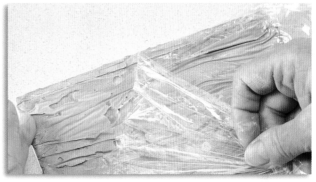

3 You can also make folds with plastic wrap.

4 If you use plastic wrap to create folds, allow the clay to dry enough that it holds the folds. Peel the plastic off the clay and allow the clay to dry completely.

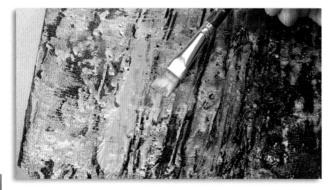

5 Paint and embellish the clay as desired.

TIPS, TROUBLESHOOTING AND MORE IDEAS

» Without the proper mixing of white glue and powdered clay, your clay may crack and fall off.
» Your base should be rigid. If it is too flexible, the clay may crack. If you want or need to work on canvas, you can always strengthen it by applying cardboard, foam core or another rigid surface to the back with glue.

Sculpture

Resin clay and Paperclay are both great for molding
shapes and carving into when dry. Use the clay alone
or add found objects for a fun piece of art.

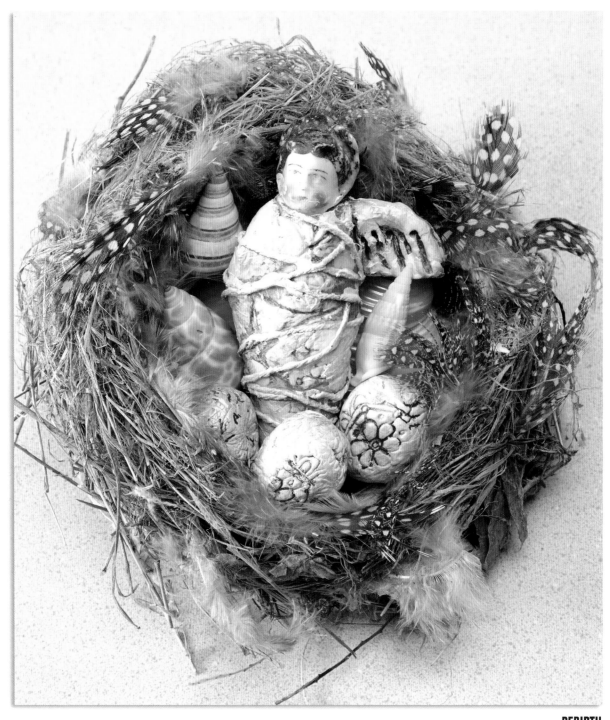

REBIRTH
DARLENE OLIVIA MCELROY
(Assemblage using Paperclay and found objects.)

68

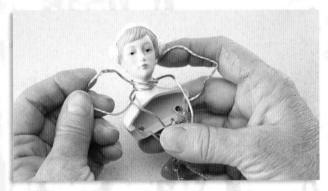

1 Make an armature by shaping your form with wire.

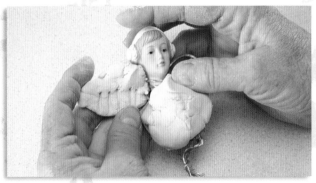

2 Add Paperclay or resin clay to the armature and sculpt.

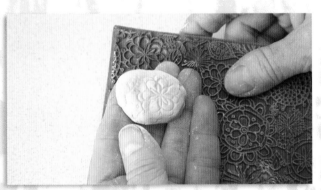

3 Stamp, sculpt or carve into the clay.

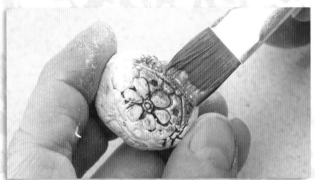

4 Paint the clay after it has dried.

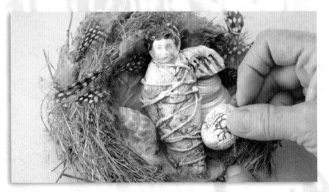

5 Add decorative elements and compose your sculpture as desired. To finish this sculpture, I've added it to a scene. Add a base or hanger. Use epoxy or silicone glue if necessary.

TIPS, TROUBLESHOOTING AND MORE IDEAS

Always check for balance. If you place your sculpture on a stand, make sure the stand is solid enough to hold your sculpture. If your sculpture is freestanding, always check all sides for visual interest and balance.

Casting

You can use a two-part molding compound that's like a putty and takes about 15 minutes to set up, or you can use a liquid latex, depending on the size of your finished piece, available time and skill level. As for the mold, you can make a mold out of anything that has texture—earrings, manhole covers, carved wooden boxes and more. Once you have your mold, you can either press Paperclay into it, or pour a mixed powdered clay or resin into it. After the clay or resin is dry or has cured, remove it from the mold and then paint it, metal leaf it, rust it or give it a patina.

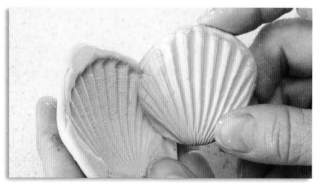

1 Take equal parts of A and B of the molding compound and mix well.

2 Press the compound onto an object you would like to duplicate.

3 Wait 15 minutes and peel the mold off the object.

4 Press the Paperclay into the mold.

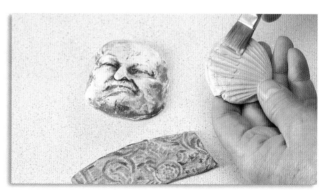

5 Lift the Paperclay out of the mold and let dry. This may take several hours or more.

6 Paint, rust, metal leaf or otherwise embellish the casting.

Stamping

Paperclay can be applied to a rough surface and then stamped, carved, shaped and painted. It adds great dimension and texture to your surface.

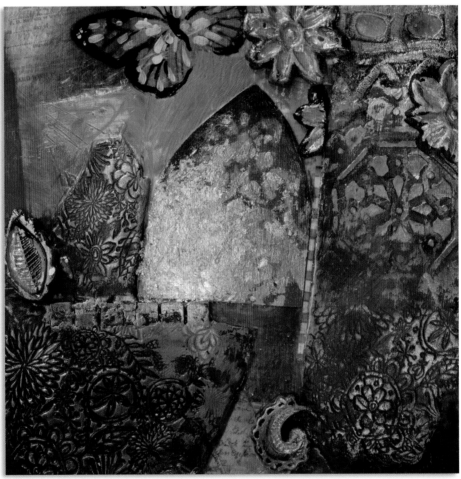

DARK GOTHIC NIGHTS TURN TO SPRING
DARLENE OLIVIA MCELROY
(Stamped Paperclay slabs and molded objects.)

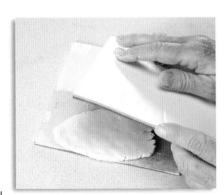

1 Lay paper clay on a semi-rough surface.

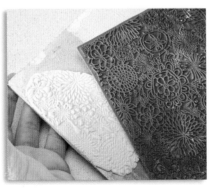

2 Stamp a texture into the paper clay. Let dry and then paint.

3 Apply paperclay objects to your surface for accents.

71

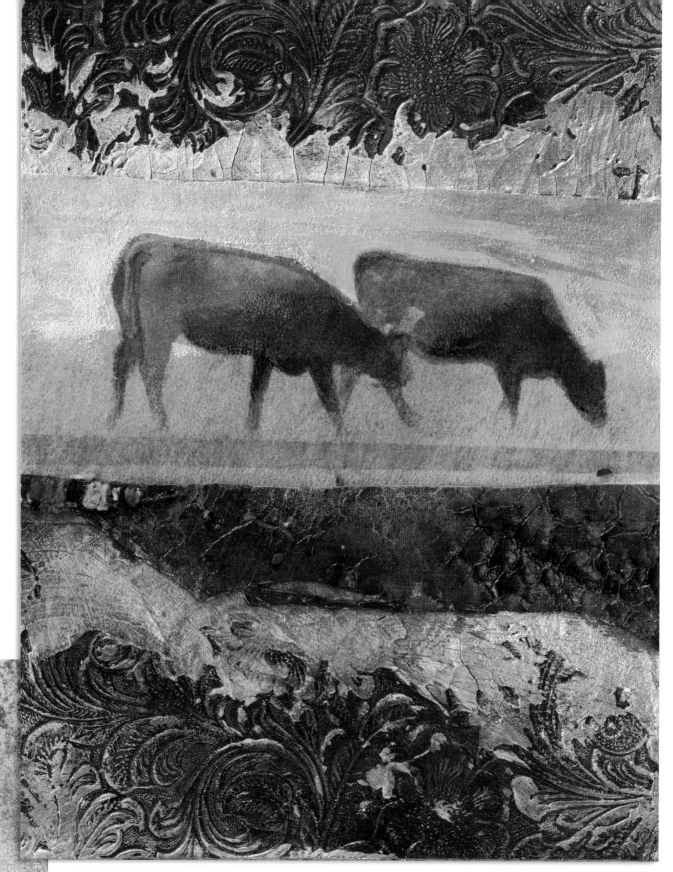

DINNER FOR TWO
DARLENE OLIVIA MCELROY
(Embossed faux leather, faux suede, real leather accents, image transfer.)

Visit artistsnetwork.com/alternative-surfaces for bonus demonstrations, tips, ideas and more!

11 RAWHIDE, SUEDE & LEATHER

Oh, the joy of suede and fake suede! Learn how to burn it, transfer onto it, paint it, shape it and draw on it. You can sew it, weave it or use it to accent your piece of art. Embossed fake leather comes in many colors and designs, and can be found at upholstery and fabric stores. Rawhide can be worked on in its hard state, or you can soak it to soften and shape it. Real leather is wonderful, but faux leathers are much more reasonably priced.

MATERIALS FEATURED IN THIS CHAPTER:

» acrylic paints
» brayer
» Conté crayons
» ephemera such as feathers, old paintbrushes, porcupine quills
» fabric

» found objects for stamping
» Krylon Crystal Clear
» lighter
» molding paste
» oil pastels
» paintbrushes

» pencil or charcoal
» Rawhide, suede and leather
» scissors or other tool for burnishing
» soft cloth

» soft gel, spray glue or sewng materials
» stencils
» substrate: canvas or panel
» suede brush
» toner image

» vintage book pages
» white gasoline
» white glue or gloss gel
» wire
» workable fixative

Preparing Your Surface

Make sure your surface is clean by wiping it with a damp cloth if it's leather, faux leather or rawhide, or using a brush if it's suede. Certain rawhide (like pig rawhide) can be very oily. To get the oil off, wipe it down with white gasoline outside or in a well-ventilated area.

Want more?
Visit artistsnetwork.com/alternative-surfaces for a bonus demonstration: *Wood Burning on Leather.*

HMMM
DARLENE OLIVIA MCELROY
(leather, acrylic paint, gold leaf and porcupine quills)

Collage & Transfers

You can fasten your elements using soft gel, spray glue or sewing. You can build layers as long as you allow each layer to dry before adding the next.

1 Spray the back of a toner image with Krylon Crystal Clear until you can see the image coming through.

2 Place the paper face down on a piece of suede or faux suede and burnish.

3 Lift the paper off the suede. If the image is soft, you can add to it by painting in detail.

4 Apply glue or gloss gel to your canvas or panel. Lay leather on the canvas and brayer. Allow to dry. Apply paint to the leather to blend the seam between the leather and the suede you will later adhere to it.

5 Use the same paint combination you used in the previous step, this time in the bottom area of the leather to highlight and unify the piece.

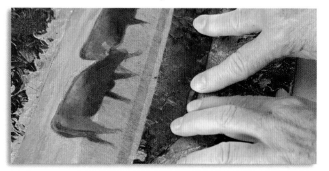

6 Brush wet glue or gloss gel on the back of the suede and carefully lay it on the leather. Brayer for best adhesion and let the glue dry completely.

TIPS, TROUBLESHOOTING AND MORE IDEAS

» Beware: If you are not careful with the glue, you will get a glue stain on your leather. So be careful.

» The best transfer for a project like this would be Krylon Crystal Clear or a solvent marker because other transfers could stain or ruin the leather.

Drawing

Rawhide and suede take Conté crayons and pastels beautifully.

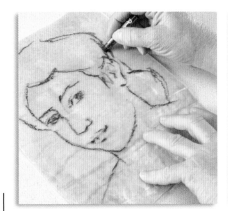

Lightly sketch an image onto mounted rawhide pigskin.

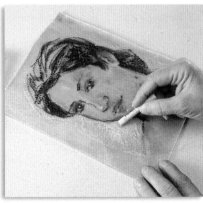

Finish your drawing with oil pastels and Conté crayons.

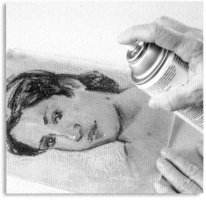

Spray with a workable fixative in a well-ventilated area to permanently set your piece.

Painting

Suede is more absorbent than leather, but both take acrylic paints well.

Paint with both thick and thin acrylic paints on a piece of leather.

Stamp onto the surface of the leather with a dark paint for shadow-like markings.

Stencil onto the leather using paint mixed with molding paste.

Rawhide Sculpture

You can take leather to another dimension, and it is perfect for book arts or for making a sculpture with added objects.

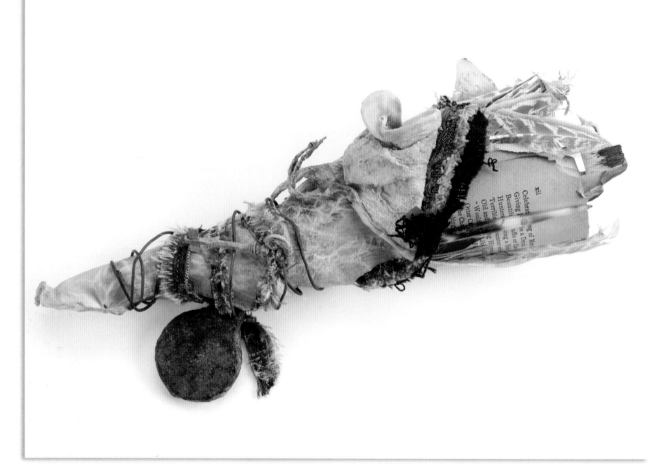

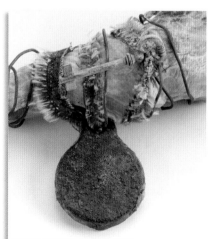

Roll a piece of leather into a cone.

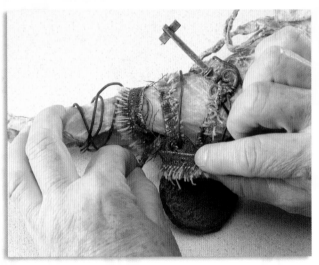

Tie the cone with wire and fabric to secure the shape.

Burn the edges of some vintage book pages and the leather cone. Place the pages in the cone.

Embellish the inner part of the cone. Add feathers, old paintbrushes, porcupine quills and whatever else strikes your fancy and tells your story.

TRAVELING ARTIST POUCH
DARLENE OLIVIA MCELROY
(Rawhide, lock, key, feathers, book pages, brushes.)

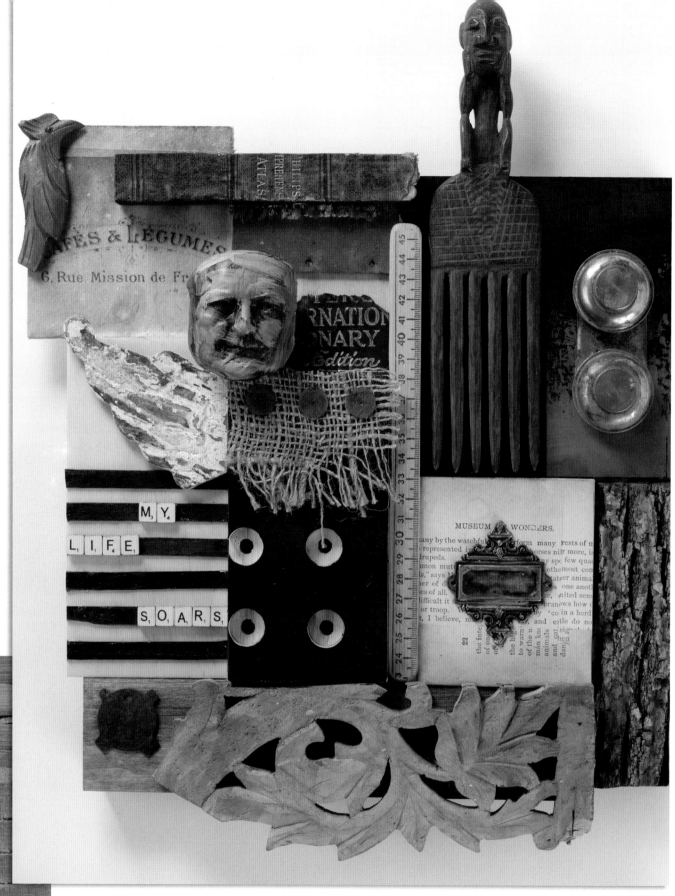

MY LIFE SOARS
DARLENE OLIVIA MCELROY
(*Wood assemblage with metal accents.*)

Visit artistsnetwork.com/alternative-surfaces for bonus demonstrations, tips, ideas and more!

12 WOOD & WOOD VENEERS

Wood's warm earthiness is the perfect surface to create with. In addition to taking plaster, paint and metal leaf well, you can also carve into it, draw or write on it with a wood-burning tool, sandblast it and use highly textured stamps on it. Plus, most transfer techniques work well on wood surfaces. You can choose to work with a chunk of wood, wood veneer, wood wallpaper or a piece of bark from a tree in your yard.

MATERIALS FEATURED IN THIS CHAPTER:

- » acrylic paint
- » camera
- » Chartpak solvent marker
- » decorative elements
- » epoxy
- » gel transfers
- » Golden Digital Ground
- » heavy book
- » inkjet printer
- » paintbrushes
- » polymer medium
- » sandpaper
- » scissors
- » silicone adhesive
- » soft cloth
- » toner image
- » toothbrush
- » waterslide decals
- » waxed paper
- » white glue or soft gel gloss
- » wood pieces, panels, objects and printable wood veneers
- » wood shims

Preparing Your Surface

Sand the wood surface if it is too rough or has a coating on it. Make sure your surface is clean and dust-free by wiping it with a damp cloth.

Printing

You can purchase wood veneers that are pre-primed for printing with an inkjet printer. You can also apply Golden Digital Ground (a receiver for inkjet) to a wood veneer prior to printing. Make sure the veneer is thin enough for your printer feed. A printer with a flat feed is recommended. You can also find companies online that will print your design on wood.

Want more?
Visit artistsnetwork.com/alternative-surfaces for a bonus demonstration: *Wood Strip Collage*.

Wood Assemblage

Creating an assemblage is like putting together a puzzle in search of a story. Start with a collection of wood objects and start organizing them until they speak to you. You may find that you have to go on a treasure hunt for more objects or that you have enough for several assemblages. If you are not sure which arrangement you like best, take a photo of each with your camera and compare them all before committing.

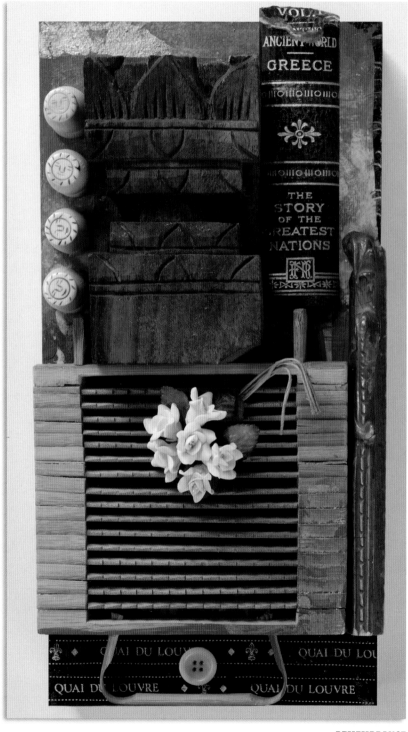

REMEMBRANCE
DARLENE OLIVIA MCELROY
(Found wood objects, book spine, ribbon.)

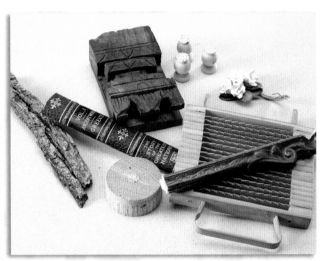

Assemble your elements and develop your composition.

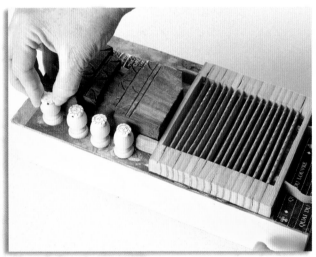

Apply white glue or soft gel gloss to individual elements and glue them together.

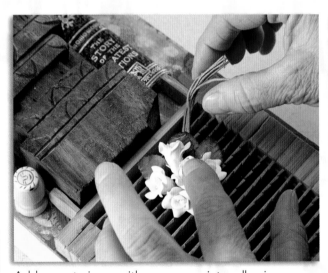

Add accent pieces with an appropriate adhesive.

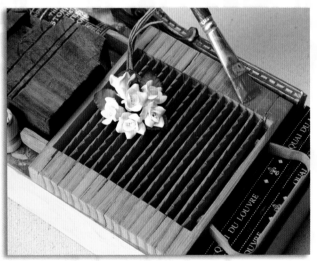

Paint areas of your assemblage as desired.

Wood Veneer Assemblage with Transfers

Though printable wood veneers are available online and in some paper stores, you can also do transfers on veneer using a solvent marker, gel transfers and waterslide decals. Wood veneers can be your painting surface, a layered surface or transformed into sculpture. Use a variety of wood veneers and sizes for added interest.

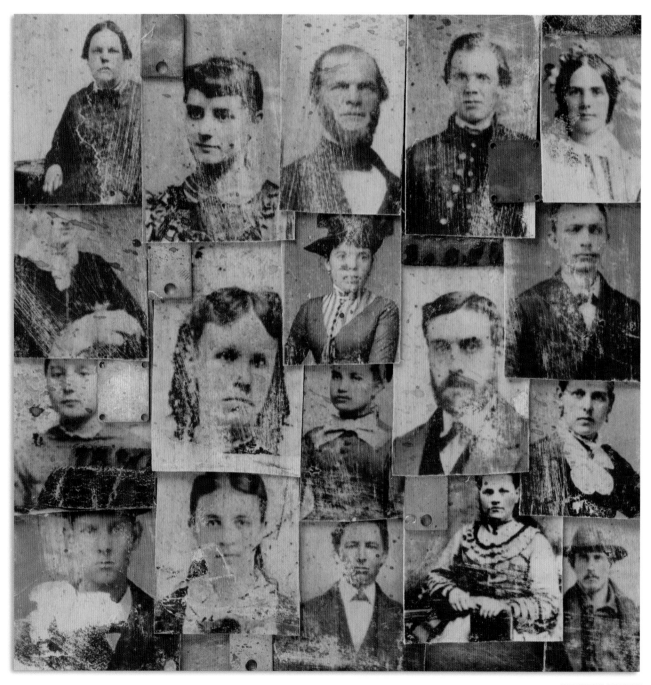

WE WERE FAMILY
DARLENE OLIVIA MCELROY
(Transfer on wood veneer.)

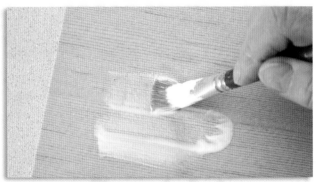

1 Apply polymer medium on the back of a piece of veneer and let it dry. (Doing this now will make it easier to trim the veneer later.)

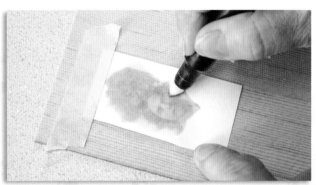

2 On the front of the veneer, do a transfer using a Chartpak solvent marker and a toner image.

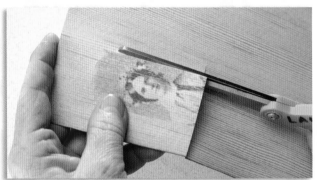

3 Cut the veneer into irregular shingles.

4 Apply epoxy to your shingles and attach them to your surface, starting from the bottom of the surface and working to the top. Lay waxed paper on the finished assemblage, add a heavy book and let the silicone dry.

5 Add decorative elements and spritz on paint with a toothbrush. Lightly sand with sandpaper.

6 For a more dimensional look, glue wood shims under some of the shingles.

TIPS, TROUBLESHOOTING AND MORE IDEAS

» A nonflexible surface like a wood panel works best as a surface for your veneer shingles. Canvas can warp and is not recommended for this project.

» For more on transfers, refer to *Image Transfer Workshop*.

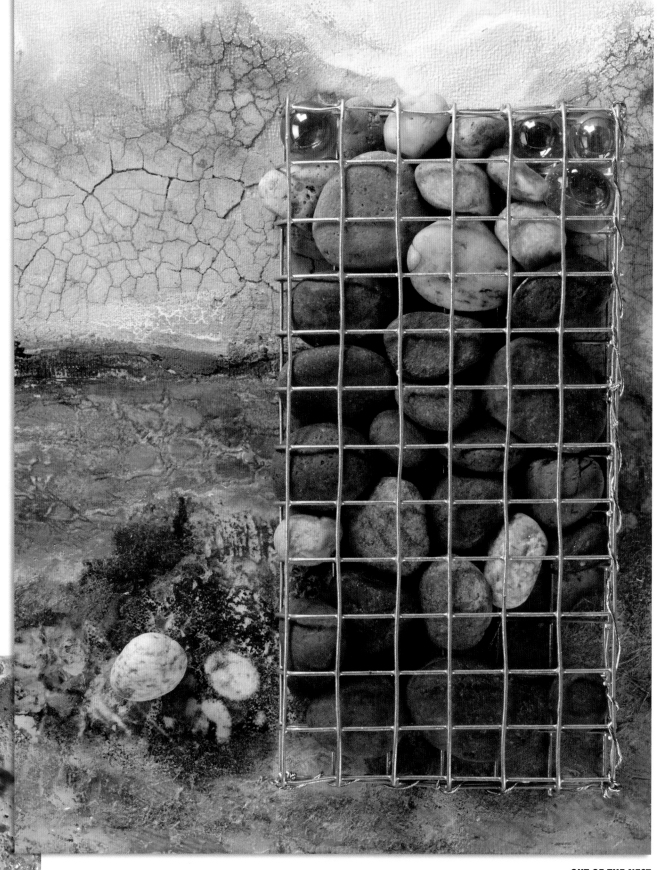

OUT OF THE NEST
SANDRA DURAN WILSON
(Stones, wire, crackle paste, acrylic paint, E6000.)

Visit artistsnetwork.com/alternative-surfaces for bonus demonstrations, tips, ideas and more!

13 STONE

Stone is probably the original art surface. Cave paintings and petroglyphs abound in many areas around the world, including my hometown of Santa Fe, New Mexico. These carvings, drawings and paintings have piqued imaginations and inspired paintings for millennia.

Stone as an art surface today is probably more recognized in the form of sculpture. I have been a stone cutter in the past, both gemstones and sculpture, but what I want you to consider is the more ancient form of painting on stone and even using stone as it is found in nature.

When cutting metal or stone, wear a mask, eye protection, protective gloves and closed-toe shoes.

MATERIALS FEATURED IN THIS CHAPTER:

- » acrylic paint
- » alcohol ink
- » burnishing tool (such as scissors)
- » Citra Solv or Chartpak solvent marker
- » coated wire
- » collage papers and dimensional embellishments
- » drill
- » epoxy
- » eyedropper
- » felt tool for alcohol inks
- » flat brush or palette knife
- » gel matte medium
- » glitter or glass beads or mica powder
- » grout
- » heat gun
- » pen or pencil
- » plate hangers, shadow box frame
- » polymer medium
- » repirator mask, goggles and gloves
- » rubbing alcohol
- » soap and water
- » tape
- » toner images
- » travertine tiles, slate tiles, small stones and pebbles
- » two-part epoxy or resin, or clay
- » waterslide decals
- » wire cutters, pliers, etc.
- » wire mesh
- » wood panels or cradled panels

Mounting Ideas

- » You may mount your stone tile onto a panel using a two-part epoxy or resin, or clay.
- » Plate hangers can be used if the stone is not too heavy or too large.
- » You may even mount the stone into a shadow box frame.
- » Mount several tiles onto wood, and grout in between.

Stone Tiles: Travertine

Travertine tiles may be found in building supply stores. Travertine is a beautiful natural stone that is cut into different sizes to be used primarily in tile applications. I frequently use the back side of the tile because it has a more interesting texture with more nooks. I have painted on travertine with alcohol inks, acrylic paints, polymer mediums, glass beads and mica powders.

SPACE ROCKS
SANDRA DURAN WILSON
(Travertine tile with alcohol inks, micro beads and textures on clay-covered panel.)

1 Apply alcohol ink directly onto the tile and then drop alcohol onto the surface to disperse the ink.

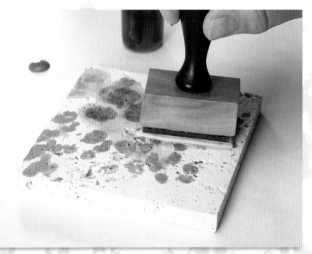

2 Put drops of alcohol ink onto a felt tool and dab onto the surface of the tile. Heat set the ink with a heat gun.

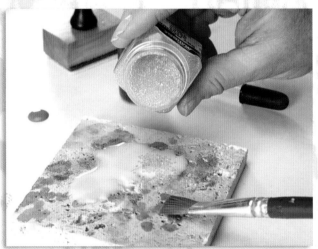

3 Pour polymer medium onto the tile and sprinkle glitter or glass beads onto the surface.

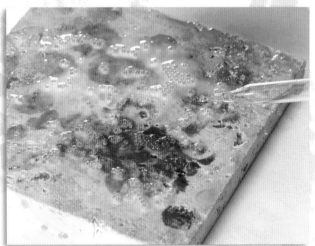

4 Work a few beads into the stone openings. Let dry.

Slate

Slate is another natural stone that works well with acrylics because of its natural porous texture and surface quality. I use both fluid and heavy-body acrylics to paint on slate tiles. Consider using the back side of the tiles because you may find interesting saw cuts and texture. I recommend gel matte medium to adhere collage papers and epoxy to adhere heavier, more dimensional elements. A flat brush or palette knife drags paint over the surface and leaves a nicer effect than a paintbrush.

HARMONY
SANDRA DURAN WILSON
(Slate tile, collage and letter tiles.)

Transfers onto Stone

Stone and stone tiles are wonderful surfaces on which to transfer images. Solvent transfers like Citra Solv and Chartpak solvent markers work especially well on porous stones. Waterslide decal transfers work best on less porous stone.

Tape a laser printed image print side down onto a stone tile. Use a Chartpak solvent marker to saturate the back of the image. Work in small sections.

Immediately burnish the image onto the stone.

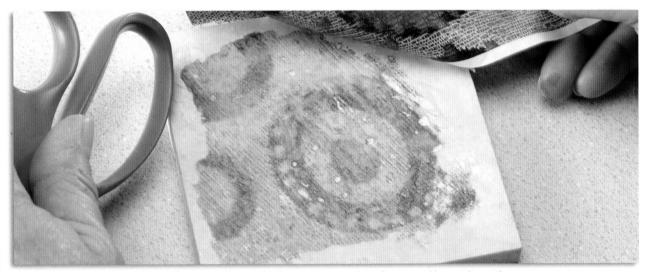

Take a look at the progress of the transfer and continue to apply solvent and burnish until your transfer is complete.

Stones

Think outside the box—or stone—if you will. Stone has been used for carving and drawing, and it's even ground to make pigments for paint. The pursuit of precious stones has launched many an adventure, and cave paintings from ancient and prehistoric times continue to inspire us.

What I want to talk about now is using stone itself, without any alteration, as an art form or element. The humble gabion, which is used to harness rocks and form barriers to prevent erosion, is experiencing a newly elevated status in the worlds of architecture, sculpture and landscape. In this project, you will form a miniature gabion to hold small stones to a wood panel. (You can print a full-size template for the gabion at *artistsnetwork.com/alternative-surfaces*.)

TIPS, TROUBLESHOOTING AND MORE IDEAS

» When working on natural stone that has not been polished, wash and dry it to remove any dirt.
» Satin and matte paints blend better with the stone, but use whatever finish necessary to achieve your desired results.

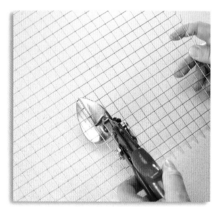 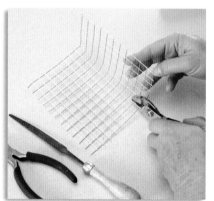 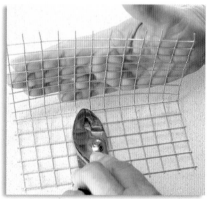

1 Cut out the metal for the gabion according to the template and use pliers to bend the metal into shape.

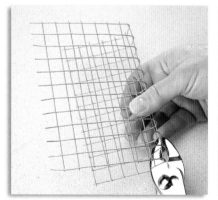 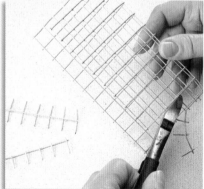 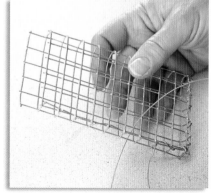

2 Continue to shape and form the gabion. Trim any excess metal and sharp edges with wire cutters. Stitch the gabion closed by wrapping with wire. I am using a coated wire for hanging art for my stitching.

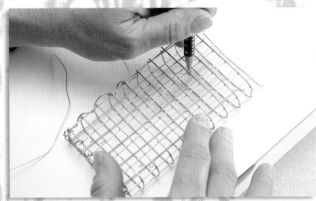

3 Place the gabion on your surface and mark holes for drilling.

4 Drill holes to be used to secure the gabion into the surface.

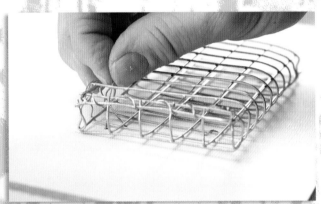

5 Attach the gabion to the surface with wire.

6 Secure the wire on the back of the surface.

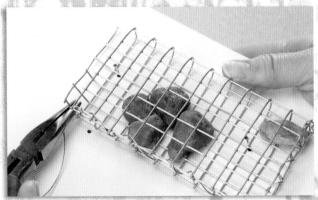

7 Fill the gabion with stones. When finished, bend the top edge of the wire to close the gabion, and stitch the gabion closed with wire.

OUT OF THE NEST
SANDRA DURAN WILSON
(In the finished piece at right, I painted the panel first and then attached the gabion. I then used epoxy to attach additional stones to the painted panel.)

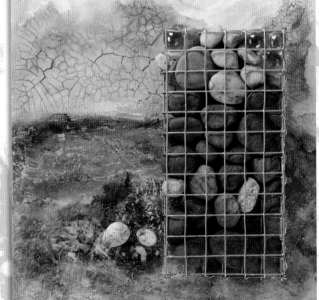

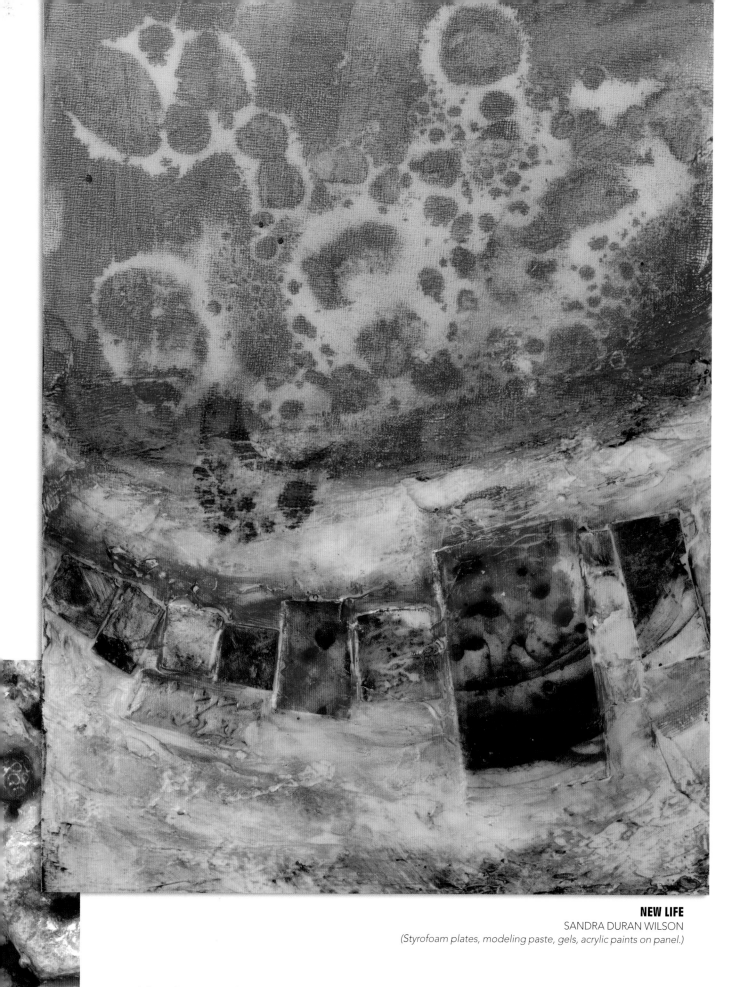

NEW LIFE
SANDRA DURAN WILSON
(*Styrofoam plates, modeling paste, gels, acrylic paints on panel.*)

Visit artistsnetwork.com/alternative-surfaces for bonus demonstrations, tips, ideas and more!

14 FLORAL FOAM, SPRAY FOAM & CELL FOAM

We use foam in its many forms in applications as diverse as crafting, packing and home improvement applications. Foam also happens to be a great surface with which to create art from and on.

MATERIALS FEATURED IN THIS CHAPTER:

- » acetone
- » acrylic medium
- » acrylic paint, watercolors, inks, markers, dyes
- » acrylic polymer medium
- » Citra Solv
- » drill
- » foam glue or glue gun
- » gel medium

- » glass beads or glitter
- » hanger
- » paintbrushes
- » pasta machine, rolling pin, brayer or cylinder
- » plastic foam-cutting kit
- » plastic tarp or sheet
- » protective goggles
- » PVA glue, gesso, gloss varnish, Future Floor Wax or Mod Podge

- » respirator mask
- » spray paint
- » stamps
- » Styrofoam, floral foam, cell foam and insulating spray foam
- » texture plate
- » wood panel, plastic box frame, wood box or cradled panel

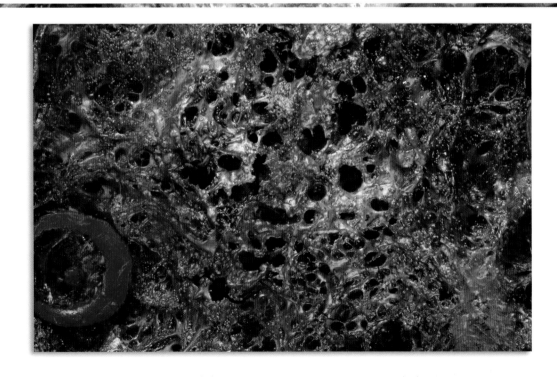

Styrofoam or Floral Foam

Styrofoam (a trademarked name for extruded polystyrene) is everywhere. You can buy it (and floral foam too) in many different densities, shapes and sizes. Using leftover packing materials is another (greener) option. Only certain glues are compatible for working with Styrofoam, and paints with solvents will melt foam (which is sometimes exactly what you might want to do!).

How to Cut and Sand Styrofoam and Floral Foam
Purchase a plastic foam-cutting kit from a hobby store; this will ensure success in cutting and shaping foam. Sand or smooth foam by using another piece of foam as a sanding block.

TIPS, TROUBLESHOOTING AND MORE IDEAS

You can use a serrated or electric knife to cut foam. Running your knife through candle wax makes cutting easier.

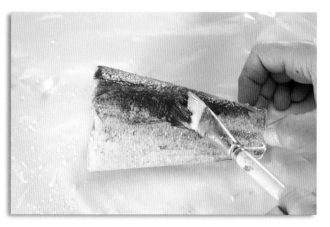

How to Seal, Glue and Paint
Styrofoam may be sealed with a PVA glue-and-water mixture, gesso, gloss varnish, Future Floor Wax and specialty products like Mod Podge. Brush your sealant of choice on the foam and set the foam on plastic to dry. You will probably need to apply two coats of sealant for best results. Let the sealant dry thoroughly. You can then paint the Styrofoam with acrylic paints, or use markers or stamps on it.

Cell Foam

This is the stuff that foam plates and cups are made of. It can be purchased in sheets from the craft store. It is also frequently used in model making. My students use foam plates as palettes in workshops, and I use them in the studio. I love to reuse those palettes whenever I can! (For more evidence of my love for reuse, see *Mixed Media Revolution*.)

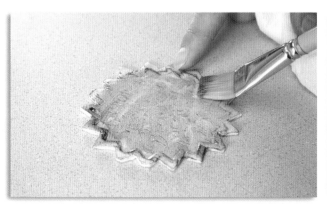

Paint
Acrylic paint adheres well to cell foam. Paint directly onto the foam for an inexpensive surface.

Use as a Collage
Cut up plates that have paint on them and embed them into gel on a wood panel. Let the gel dry and finish painting or add details. The foam pieces are like collage papers or mosaic pieces.

Emboss
I took a texture plate, put it onto the foam and ran it through my pasta machine to get a nice embossing. You can do it by hand with a rolling pin, brayer or cylinder.

TIPS, TROUBLESHOOTING AND MORE IDEAS

» You can use specialty foam glues or even a low-temp hot glue gun to adhere cell foam to itself and to other surfaces.

» **Heat and Shape**—Heat your foam just a little bit and it becomes quite malleable and shapeable.

» **Sculpture**—Cut, shape and glue several pieces together to create a sculpture.

» **Transfers**—You can transfer a laser image onto cell foam with a solvent like a Chartpak solvent pen or Citra Solv.

» **Jewelry**—You can also make jewelry from cell foam mosaic pieces. Earrings and lightweight pendants are a natural.

Melting Foam

If you want to melt Styrofoam, *do not* seal it. This technique should be done outside. Wear eye protection and take all necessary precautions. Seriously. Don't mess around with the potentially toxic fumes produced by burning foam. You can use acetone to melt foam, but you won't have much control over the process. You can use Citra Solv, but the process is a slow one and it leaves behind an oily residue.

My favorite technique for melting Styrofoam involves spray paint. Use regular spray paint, not the type for use with foam or plastics. Again, be sure to do this outside, and leave the foam outside for several hours to allow the fumes to dissipate.

Spray the Styrofoam with regular spray paint. (I used gold spray paint for a metallic look.)

The spray paint will eat away at the surface of the Styrofoam. Leave the Styrofoam and paint to dry, which will take several hours.

Highlight the melted foam with acrylic paint as desired.

You can embellish the foam with glass beads, glitter and whatever else you can think of. Seal with an acrylic medium.

IDEAS FOR MOUNTING AND DISPLAY

» Mount your Styrofoam in a plastic box frame: Cut the Styrofoam to size. Drill a couple of holes into the plastic box through which to attach a hanger. Spray paint the inside of the plastic box. When you are finished melting and painting the Styrofoam, use a Styrofoam-compatible glue or gel medium to adhere the foam inside the frame.

» I painted a piece of cast acrylic with transparent glazes, placed it on top of my Styrofoam and sealed the foam in with black tape.

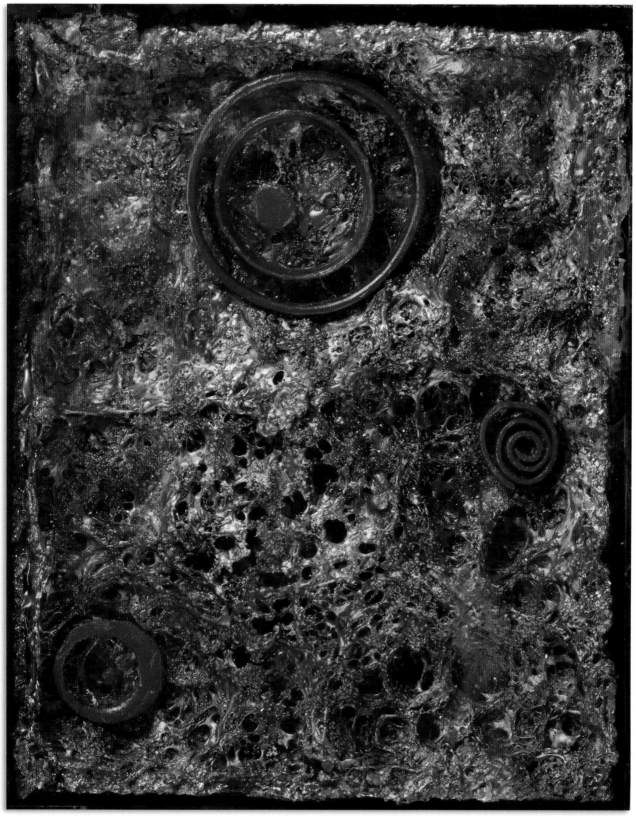

NEW WORLDS
SANDRA DURAN WILSON
*(Spray paint-melted foam, circles cut from cell foam
cups, acrylic paint, beads and acrylic medium.)*

Spray Foam

Great Stuff is just one of the readily available brands of insulating spray foam that you'll find in your local home improvement store. It is intended to seal gaps around openings for insulation purposes. Of course, our intentions are quite different …

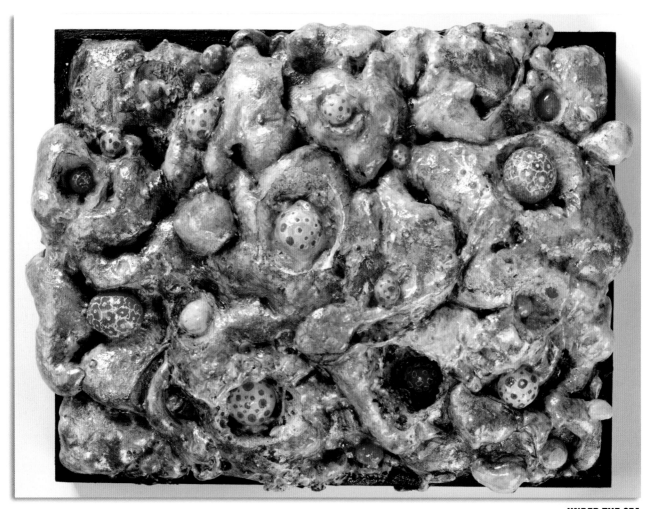

UNDER THE SEA
SANDRA DURAN WILSON
*(Spray foam, wood box, acrylic paints,
permanent markers, glass beads.)*



How to Apply Spray Foam to Wood and Plastic

Spray the foam into a wood box. Be careful not to spray too much foam; this stuff expands A LOT. Let the foam dry. You can spray some foam into shapes and balls by spraying onto a sheet of plastic. The foam will stick to the wood but not the plastic. You can also cut dried foam into shapes and adhere them to other foam.

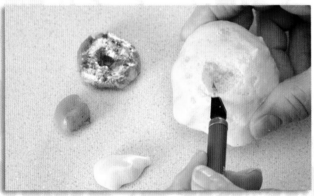

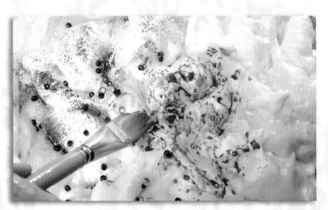

Painting, Gluing and Sealing

Once the foam is dry, you can paint it with acrylic paints, watercolors, inks, markers and dyes. Just play and have fun. You can even sprinkle beads or lightweight materials into the foam while it is still wet. Use acrylic medium to attach foam shapes. When you are finished creating your spray foam masterpiece, let it dry, seal it with an acrylic polymer medium and let the medium dry completely. The foam will deteriorate if left outside unpainted due to the exposure to UV rays. I doubt the spray foam is archival or that we can anticipate a long-lived piece of art from it, but it is fun, and that's what is important!

TIPS, TROUBLESHOOTING AND MORE IDEAS

» You can cut shapes out of cardboard and spray the foam over the cardboard shapes. You can then use a box cutter to carve away any foam overflow and get the pieces back to the original cardboard shapes. We made all kinds of great props in high school drama class with this stuff, like big boulders that could be quickly and easily moved between sets on stage. What can you come up with?

» To mount your finished piece, you should drill holes and mount hanging hardware before you begin spraying foam. If you forget, though, no worries! This stuff is so light you can glue a hanger on after the fact if you need to.

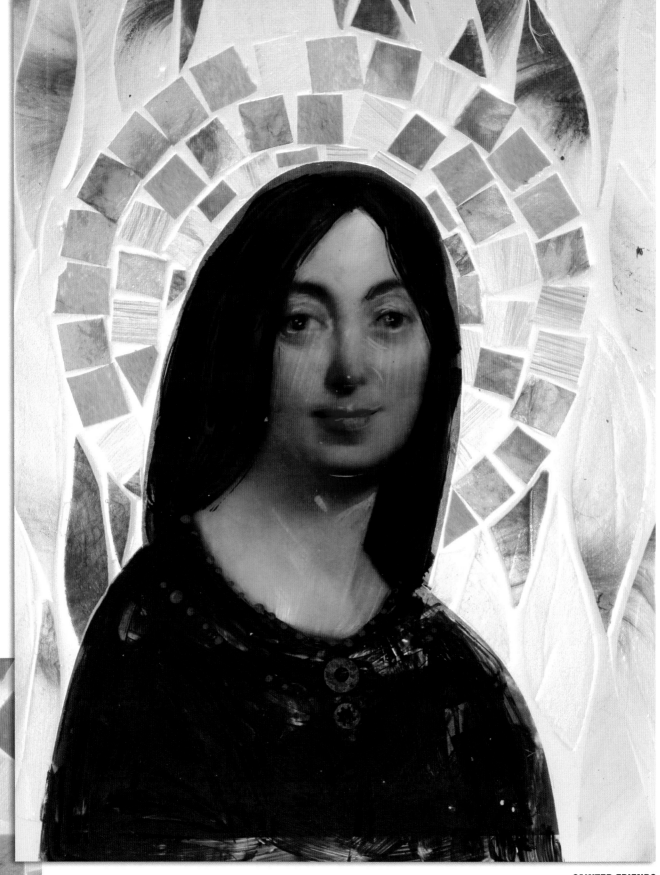

SAINTED FRIENDS
DARLENE OLIVIA MCELROY
*(Acrylic skins used as a stained glass mosaic
on Plexiglas with image transfer.)*

Visit artistsnetwork.com/alternative-surfaces for bonus demonstrations, tips, ideas and more!

15 ACRYLIC SKINS

Think of acrylic skins as paintings floating off the canvas. Acrylic paint is wonderfully pliable and versatile. You can use any polymer medium or gel and any color paint to make a skin. You can embed objects and create textures in skins, and you can make opaque and transparent skins. Skins made out of acrylics can be sculpted, hung or used as part of a larger painting. You can make them as thick or thin as you like. You can make them ahead of time and have several on hand as collage elements.

Store acrylic skins between sheets of waxed paper so they don't stick together.

MATERIALS FEATURED IN THIS CHAPTER:

- » acrylic paint
- » carrier paper
- » craft knife
- » drill
- » glass or Plexiglas

- » Golden Digital Ground or inkAID
- » hanger (such as wire, string or ribbon)
- » inkjet or toner printer

- » metal leaf or metal leaf crumbles
- » paintbrushes
- » plastic cutting board
- » polymer medium

- » polymer medium gloss
- » rubber stamp
- » scissors
- » sheet of Plexiglas, glass or polypropylene plastic

- » spray bottle filled with rubbing alcohol
- » tape
- » waterslide decal
- » workable fixative

Want more?
Visit artistsnetwork.com/alternative-surfaces for a bonus demonstration: *Creating an Acrylic Skin Hanging Sculpture.*

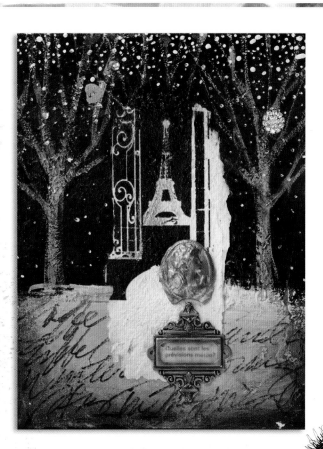

Making Acrylic Skins

Use a sheet of glass, a plastic cutting board or a piece of polypropylene plastic as a surface to work on. When the acrylics have dried, you can peel the skin off the surface.

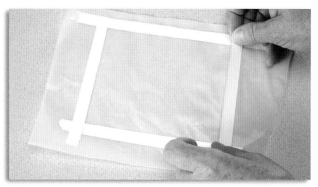

1 Lay tape down on your work surface to make it easier to lift the skin off the surface.

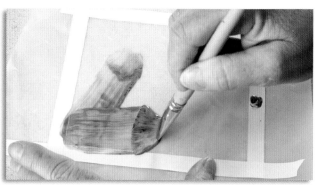

2 Paint a layer of polymer medium and let dry. Pour or paint with acrylic paint onto your work surface.

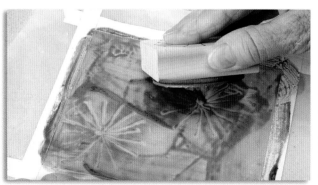

3 Stamp into the wet paint to add texture to the skin. Let dry.

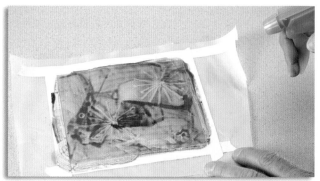

4 Acrylic skins hold metal leafing well. Spray alcohol on a skin and wait for the surface of the skin to get tacky.

5 Add metal leaf or metal leaf crumbles and pat the leaf into the skin. You will have to seal the leaf or it will tarnish.

6 Remove tape and lift the skin from the surface. You may have to cut along the tape's edge with a craft knife to separate the skin from the tape.

TIPS, TROUBLESHOOTING AND MORE IDEAS

» Acrylics inks, paints and spray paints work well with this technique.
» You can add many kinds of transfers to the acrylic skin—go ahead and experiment!

Painted Skin Accents

These skins can be added to a painting as an accent, or a painting can be totally comprised of these pieces. You can also stencil or drip acrylic paint onto plastic.

Peel these shapes off the plastic after they've dried and adhere them to your painting.

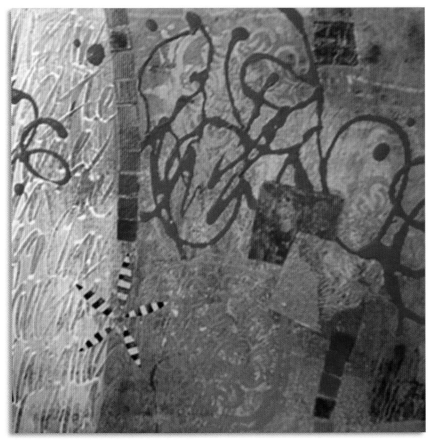

THE MIND IS A CRAZY PLACE
DARLENE OLIVIA MCELROY
(Acrylic skins, shapes and squiggles used as accents.)

Paint specific or abstract shapes onto plastic.

When the skin is dry, peel it off the work surface.

Apply the skin as an accent with polymer medium.

Printing

Apply Golden Digital Ground (which is a receiver for inkjet) to an acrylic skin (in this demonstration I used acrylic fiber paste to make my skin). Let the digital ground dry and then attach the skin to printer or carrier paper before printing on it. Make sure the skin is smaller than the paper. Spray with a workable fixative.

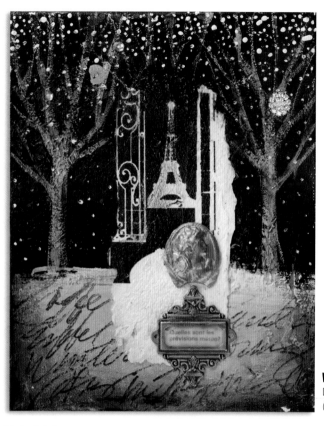

TIPS, TROUBLESHOOTING AND MORE IDEAS

Do not use in a laser printer because the heat will stretch the skin and glue it into your printer!

WINTER IN PARIS
DARLENE OLIVIA MCELROY
(Printed acrylic skin on painting.)

Apply Golden Digital Ground or inkAID to a skin, and allow it to dry. Attach the skin to a carrier paper by taping the skin to the paper along the top and bottom edges.

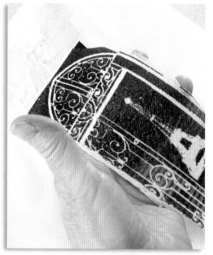

Print the image of your choice on the skin using an inkjet or toner printer.

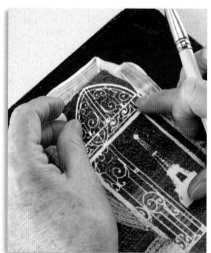

Spray the printed image with a workable fixative before using in your art.

Acrylic Skin Mosaic Stained Glass

These faux mosaic pieces can be used on glass or Plexiglas objects through which light can pass. By adding solid, iridescent and metallic color to your paint skins you will end up with a wonderful mix of pieces. Mix soft gel gloss with paint to create a transparent look.

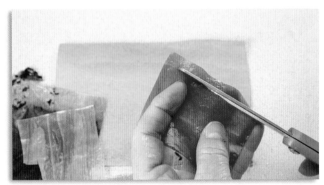

1 Cut acrylic skins into mosaic-sized pieces (or sizes appropriate for your final design).

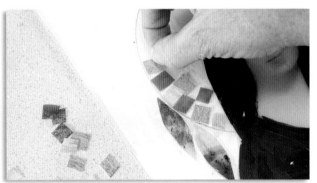

2 Apply a waterslide decal to a piece of Plexi. (The Plexi should have holes drilled in the two top corners so a hanger can be added.) Apply skin pieces around the image using polymer medium gloss as a glue. Let dry.

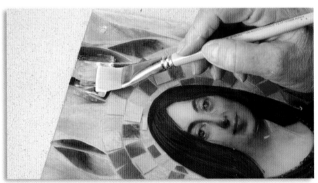

3 Brush a layer of polymer medium gloss over the entire surface. Let dry.

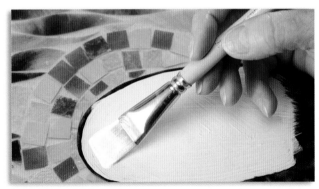

4 Flip the Plexi over and paint a layer of light tan paint behind the transfer. This will make that area more opaque.

5 Add a hanger.

TIPS, TROUBLESHOOTING AND MORE IDEAS

Try using transparent and opaque skins for variety.

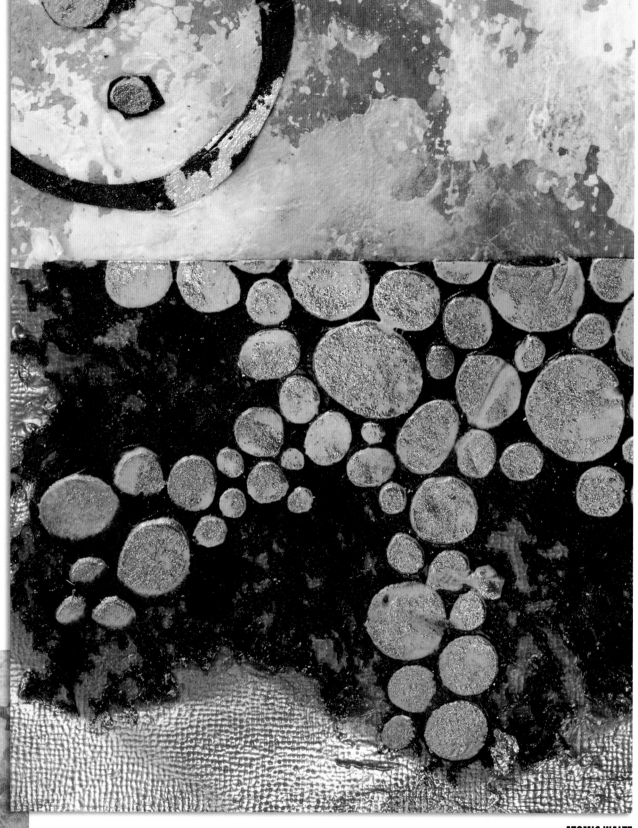

ATOMIC WALTZ
SANDRA DURAN WILSON
(The highlight of this piece is Lutradur, a synthetic polyspun fabric. It comes in white and black and different weights. You can paint on it, stamp it, burn it, transfer onto it and, of course, sew it. Painting on Lutradur with acrylic paint protects the fabric from heat distress. Use a stencil [I used a StencilGirl stencil] to apply molding paste to a piece of black Lutradur. Let the molding paste dry and apply paint. Heat the Lutradur with a heat gun to distress the fabric, creating a lacy pattern. Mount it to a panel or other surface with heavy gel. Apply copper leaf, paint and whatever else you wish.)

Visit artistsnetwork.com/alternative-surfaces for bonus demonstrations, tips, ideas and more!

16 SPECIALTY PAPERS

Specialty papers are everywhere today. I am a paper lover and whenever I travel, I am always on the hunt for new and unusual papers. The papers I use in this chapter include Yupo, Dura-Lar, Lutradur, viscose and bark or Amate paper. All will give your work a unique layer, and they can be used as your surface. Some are transparent, others opaque and waxy looking, and some are like fabric.

The archival aspect is known for some, and others are experimental. I will talk about those aspects individually.

MATERIALS FEATURED IN THIS CHAPTER:

- » acrylic and watercolor paints
- » brayer
- » gel medium gloss, matte or satin
- » glass, Plexiglas, wood panels, stretched canvas
- » glazing medium
- » inkjet or laser printer
- » paintbrushes
- » pencils, water-soluable crayons
- » plastic sheet or tray
- » scissors
- » spray bottle filled with water
- » workable fixative or spray varnish
- » Yupo, Dura-Lar, Mylar, bark or Amate paper, viscose

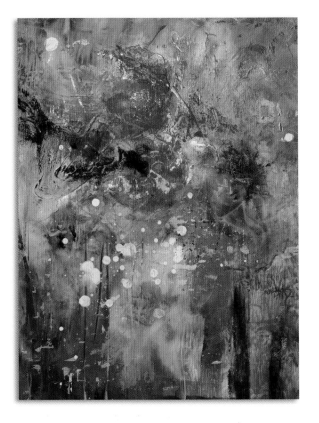

TIPS, TROUBLESHOOTING AND MORE IDEAS

If you are using any of these papers to create book pages, you may wish to coat them with a product to keep them from sticking together. Decoupage medium comes in matte and gloss finishes and is nonstick when dry. A clear gesso or acrylic ground for pastel will work also. Dilute a small amount of water into clear gesso or ground and rub the mixture into the paper. Let the paper sit for a few minutes and then rub off any excess mixture. You are aiming for a slightly gritty surface. A dusting of baby powder may also do the trick.

Yupo

Yupo paper is a synthetic water-resistant paper. All drying is done via evaporation and there will be no absorption by the paper. This presents some unique possibilities. Yupo is actually not a paper at all; it was originally developed for commercial labels. It is tear-proof, and paint can be added and removed with ease and without damaging the surface. Yupo is available in opaque and translucent. It is archival and has been used by watercolor and mixed-media artists for years. Now it's your turn to try something new.

Print
Cut Yupo to size and print on it with either an inkjet or a laser printer. Inkjet prints will be water-soluble and will need to be fixed. Krylon Workable Fixative or a spray varnish will do the trick. Laser prints will not require a fixative.

Paint and Draw
You can paint on Yupo with water-colors or acrylics. Acrylics should be applied in very thin layers. Pencils and water-soluble crayons also work beautifully on the surface of Yupo.

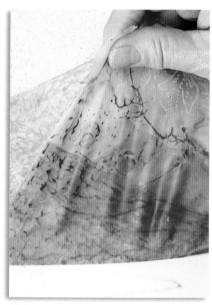

Skins
Yupo is an easy surface upon which to make acrylic skins. Once acrylic paint has dried on Yupo, apply a thick layer of gel medium gloss. Let this dry completely. It may take a while depending on temperature, etc. Once dry, the acrylic skin peels easily off the Yupo.

MOUNTING

Use a satin or matte gel to mount the paper to a panel; you'll get better adhesion than with a gloss. Spread a layer of gel onto the panel and quickly place the Yupo. Use a brayer to roll the Yupo down and eliminate bubbles. Weight the surface overnight or for a few days and let dry.

Dura-Lar

I use a product from *grafixarts.com*. It comes in both transparent and matte versions. Dura-Lar Wet Media film is the transparent one, and it is used as an acetate alternative. It is treated on both sides to accept water-based mediums. It is archival and heat resistant.

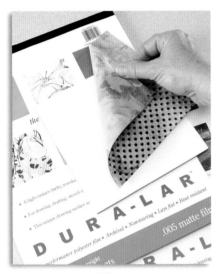

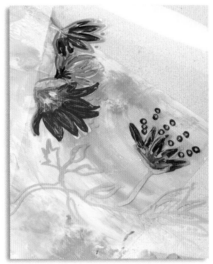

Transparent Film
You can print, paint, draw, collage, embed, apply transfers to and even work on both sides of the film. I love this stuff. It is fun to do reverse painting onto the transparent film.

Waxy Look
The Dura-Lar Matte film has all the same qualities of the clear film except you get this built-in waxy look. I love to use this product to create fast and fun faux encaustic paintings.

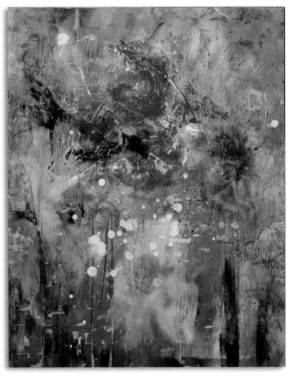

FAR FAR AWAY
SANDRA DURAN WILSON
(Matte Dura-Lar, acrylic paints.)

MOUNTING

Mount the same way you would mount Yupo. You may also use this as a layer between pieces of Plexi.

Mylar

It's fun to print your photographs onto either Mylar or overhead transparency film, and this can be done with a standard laser or inkjet printer. You can even layer images. Here are some easy and fun ways to display your printouts.

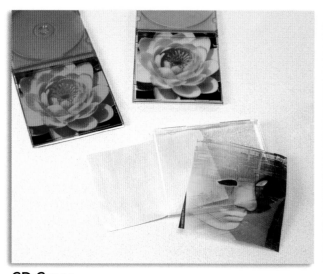

CD Cases
Cut Mylar-printed photos to size, put them inside CD jewel cases and arrange on a wall, table or shelf.

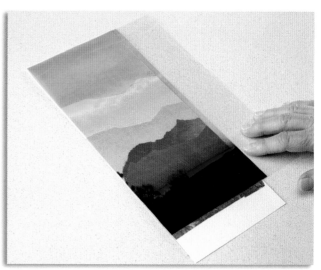

Plexiglas
Layer collage papers behind the transparency. Adhere with spray adhesive or double-sided tape. Sandwich the transparency between two pieces of Plexi, and screw or bolt the Plexis together. Attach a hanger if desired.

Bark or Amate Paper

Bark or Amate paper is made in Mexico from the bark of the mulberry tree. It shows the wonderful textures and patterns of the bark and is very absorbent.

Mix acrylic paint with glazing medium (rather than water) to keep the paper from getting too wet and breaking down. The painted paper can be framed as is, mounted onto a panel or canvas, or used as an element in another piece of art.

Viscose

Viscose is a synthetic product that is similar to fabric but is highly absorbent.

Place viscose on top of a plastic sheet or tray. Add a little paint and spray the paint with water until both the paint and viscose are saturated.

Spread the watered-down paints with a brush.

TIPS, TROUBLESHOOTING AND MORE IDEAS

You can also dip the edge of the viscose into a pool of watery paint, and the viscose will wick up the paint.

You may cut the viscose to the size of printer paper and print on it. You will need to spray the printed viscose with a fixative if you use an inkjet printer. You can also paint on top of printed viscose.

Interleaving paper may be a less expensive substitution for viscose, but note that it is not as absorbent.

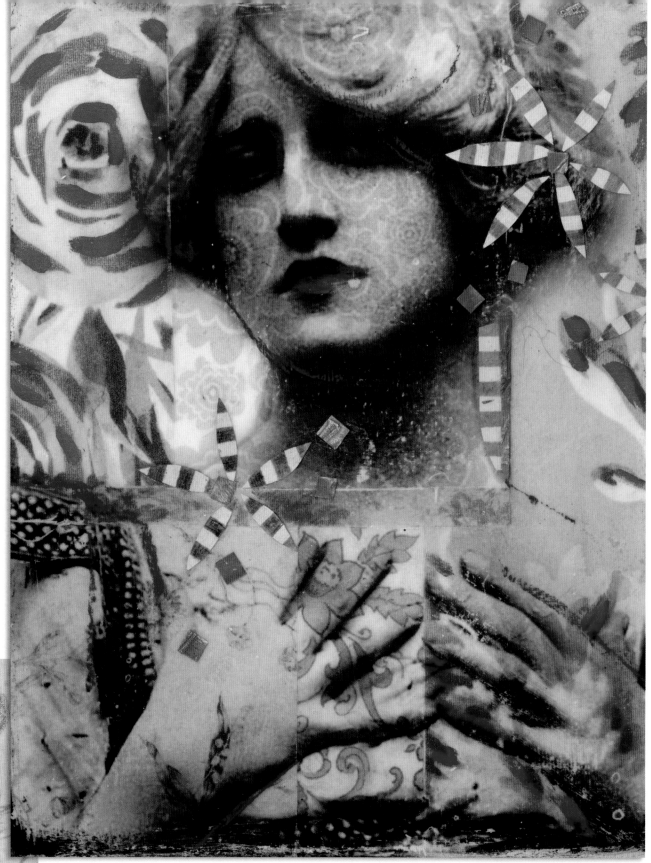

WAITING FOR THE RIGHT MOMENT
DARLENE OLIVIA MCELROY
(Woven fabric, image transfer, collage.)

Visit artistsnetwork.com/alternative-surfaces for bonus demonstrations, tips, ideas and more!

17 FABRIC

Think of the patterns, the textures, the different weights and the possibilities. You can leave it plain, paint on it, gold leaf it and even make a sculpture with it. Set a mood by using vintage fabric or pieces of old lace or napkins. Burn it, weave it, rust it. Try encasing ephemera between layers of transparent or semitransparent fabric or fusible web. Create an artist's book with pages made of fabric. Start a patterned painting by stretching fabric over stretcher bars or gluing it to a panel. And of course, you can transfer onto fabric.

MATERIALS FEATURED IN THIS CHAPTER:

- » acrylic paint
- » butcher paper
- » collage elements
- » fabric stiffener or gesso
- » heavy matte gel
- » inkjet or laser printer
- » inks, watercolor paints, metal leaf, spray paint
- » iron
- » needle and thread or sewing machine
- » paintbrushes
- » paper-backed printable fabric, muslin, fabric scraps, fabrics of your choice
- » polymer medium
- » ribbon and decorative items
- » rubber stamps
- » sandpaper
- » scissors
- » soft gel gloss
- » spool of thread
- » stiff brush
- » stretched canvas or wood panel
- » watercolor paper
- » waterslide decals
- » workable fixative

Printing on Fabric

You can find paper-backed printable fabric in craft stores and on the Internet, but you can also create your own.

1 Cut a piece of butcher paper to measure 8½" × 11" (22cm × 28cm) or the paper size of your printer. Cut your fabric slightly smaller.

2 Iron the fabric (like muslin, for example) to the shiny side of the butcher paper.

3 Cut off any loose threads.

4 Print on the fabric with your printer.

5 After printing, spray the fabric with a workable fixative if you used an inkjet printer and peel the fabric off the paper.

TIPS, TROUBLESHOOTING AND MORE IDEAS

- » If you printed your fabric using an inkjet printer and the ink runs when you paint over it, you probably did not spray enough workable fixative on it.

- » You will get a better printer image with smoother fabric, so iron away!

- » If you are using a porous fabric, you may want to coat it with Golden Digital Ground first for better ink adhesion.

Transfers and Collage

Fabrics are a great way to create a fast, easy and colorful background. You can paint them on top of a base or add a transfer on top. If you are going to add a transfer, make sure that you have a quiet area for your focal point. A heavy pattern over a face will obliterate it. My friends who sew keep their remnants for me, or I print my own fabric.

1 Glue scraps of fabric to your surface with soft gel gloss. Let the glue dry completely.

2 Apply polymer medium to the surface. While wet, apply the waterslide decal, brushing out any bubbles. Let dry.

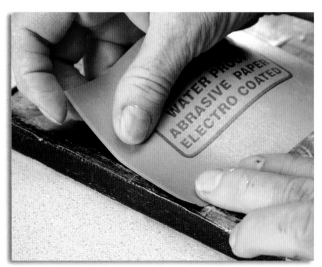

3 Sand back parts of the decal. Sanding looks most natural around edges and seams.

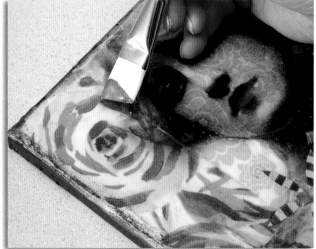

4 Paint accent areas.

TIPS, TROUBLESHOOTING AND MORE IDEAS

» If you are unsure how your image will look on the fabric, make a transparency of your image and lay it over the fabric. If it doesn't work, try another image or different fabric. You can always use the transparency in another project.

» Your image will transfer better if your fabric is as smooth as possible, so get out the iron!

» Brush bubbles out from under the waterslide decal with a stiff brush, working from the center out to the edges.

» Iron-on, solvent marker and Krylon Crystal Clear transfers also work well on fabric.

Collage, Painting and Sewing

Why not make a wonderful fabric collage? Acrylics, inks, paint, metal leaf and spray paints all work well with fabric, but each will take differently depending on what kind of fabric you use. Burlap and chiffon are two examples of fabrics that will respond differently to the same medium. You may want to coat some fabrics with an application of polymer medium before adding paint—if you want your fabric to be less absorbent than it is naturally. Fabrics with texture can also make great stamps. And of course you can sew fabric layers together, but why not try layering painted transparent fabric and sewing it to paper or vellum!

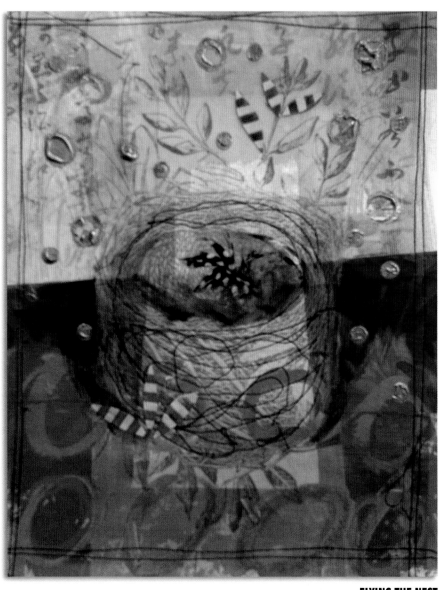

1 Start with watercolor paper and add paint.

2 Layer fabric, collage and stamping.

3 Finish by sewing with an industrial needle.

FLYING THE NEST
DARLENE OLIVIA MCELROY
(Fabric, feathers and collage on fabric.)

Shoe Sculpture

When working with fabric to make a sculpture, weight and stability of the fabric are key issues. You can use a fabric stiffener, but sometimes just gessoing and painting the back of your fabric is enough. You must also decide if your fabric sculpture is going to be a freestanding piece (with or without an armature) or a wall piece. The possibilities are endless. (You can print a full-size template for the shoe sculpture at *artistsnetwork.com/alternative-surfaces*.)

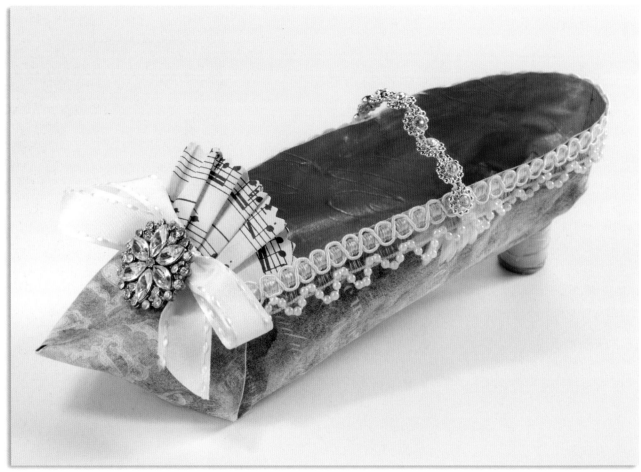

GOING BAROQUE
DARLENE OLIVIA MCELROY
(Fabric, sheet music, ribbon, earring.)

 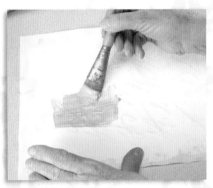

1 Before cutting the fabric to the template, gesso the reverse side. Let the gesso dry.

2 Add a layer of color. Let dry.

3 Cut the pattern using the template.

 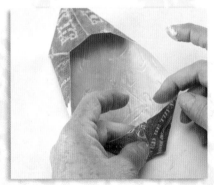

4 Glue the cut sides together as shown to form the shoe. Heavy matte gel is your best bet for hold and longevity.

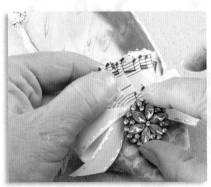

5 Add ribbon and decorative touches as desired.

6 Add a heel. A spool of thread makes a cute heel that keeps with the textile theme.

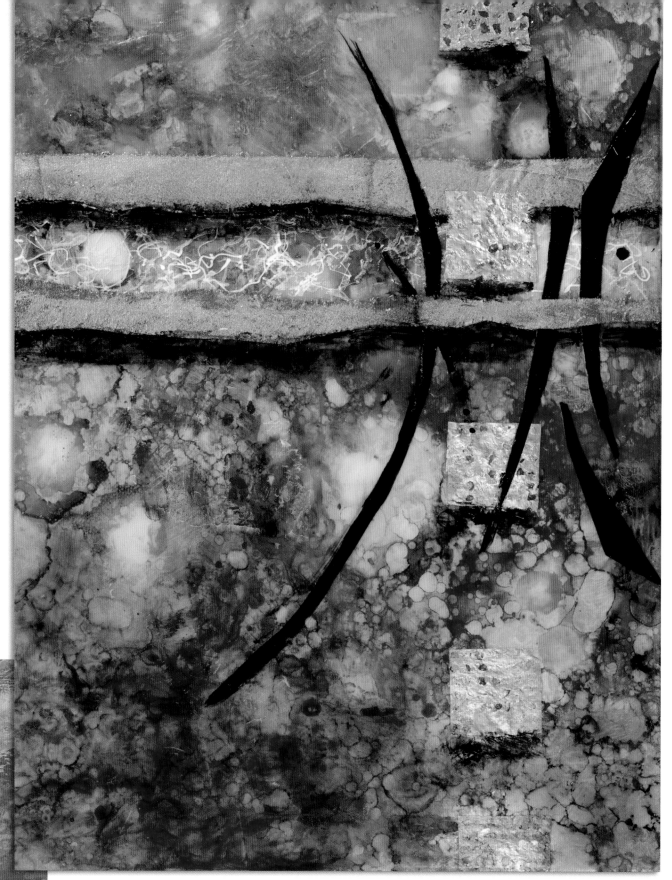

VENUS ORBITS
SANDRA DURAN WILSON
*(Alcohol inks, acrylic paints, paint pen and
collage on vinyl sheeting.)*

Visit artistsnetwork.com/alternative-surfaces for bonus demonstrations, tips, ideas and more!

18 NYLON, VINYL & LINOLEUM

The modern age has given us many new materials to work with and, really, we are only scratching the surface with this book! There is so much more to explore. I do a lot of my art supply shopping in some unusual places, including apparel, hardware and fabric stores. Nylon, vinyl and linoleum are a whole new territory for me. What I can say now is that I am wowed by the possibilities. I'll definitely be working with these man-made materials a lot more in the future.

MATERIALS FEATURED IN THIS CHAPTER:

- » acrylic gels
- » acrylic paint
- » adhesion promoter (Dupli-Color)
- » alcohol inks
- » collage materials including gel transfers
- » drill
- » epoxy adhesive

- » fabric stiffener
- » gloss gel
- » looped wire or pin (2)
- » metal painting kits (2 in contrasting colors)
- » nylon (women's stockings), upholstery vinyl, linoleum

- » opaque paint
- » paintbrushes
- » papier mâché egg
- » patina kits (2 in contrasting colors)
- » polymer medium
- » plastic tarp or sheet
- » rubbing alcohol or alcohol wipes
- » sandpaper

- » scissors
- » sealant
- » Sharpie paint pens
- » spray bottle filled with rubbing alcohol
- » staple gun
- » stretched canvas
- » stylus or other sharp tool
- » towel

- » wire coat hanger
- » wood block, 4" × 4"(10cm × 10cm)
- » wood- or linoleum-carving tools
- » wood panel, 8" × 8" (20cm × 20cm)

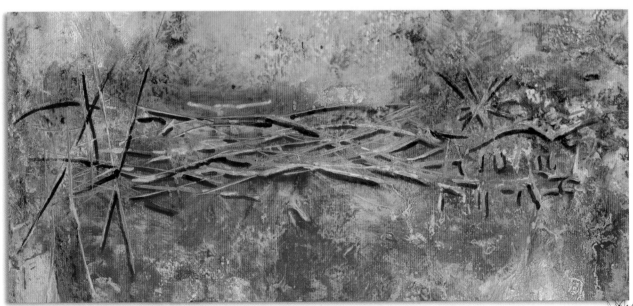

Nylon Sculpture

Nylon pretty much replaced silk in the early to mid 20th century. Women's stockings are the most readily available form of nylon, and that is what we are going to use for this demonstration. Many people will delight in using nylons as an art material rather than a fashion necessity.

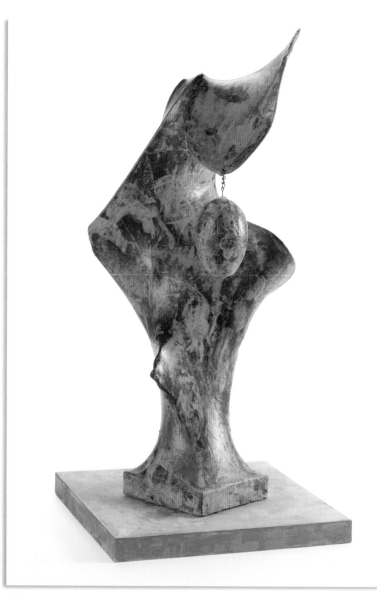

TIME WARP
SANDRA DURAN WILSON
(Nylon stocking, wire coat hanger, patina kits, wood blocks, wire and papier mâché egg.)

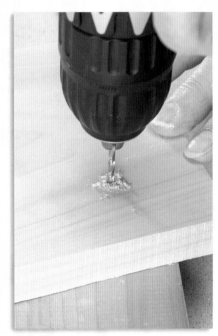

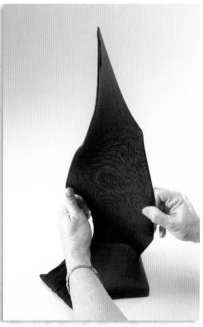

1 Drill two holes the size of the coat hanger into your wood block.

2 Untwist the wire or clip off the hanger part of the hanger and insert the wire ends into the wood. Twist the wire into an abstract shape.

3 Carefully pull a nylon stocking over the wire and wood block.

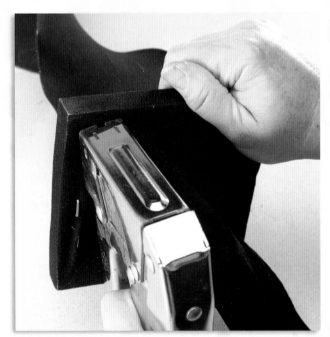

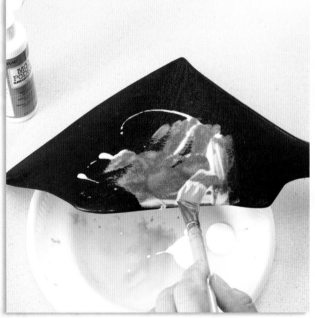

4 Staple the ends of the nylon to the bottom of the wood block. Apply glue to further stabilize and secure. Let dry.

5 Protect your work surface with plastic. Coat the nylon with fabric stiffener. Let dry. You may need a second coat of stiffener (see Tips, next page). Apply the paint from the metal painting kit. Let the paint dry overnight.

Apply a second coat of paint, and while this coat of paint is still wet, apply the patina. Apply sealant to the entire sculpture and let dry.

I also painted and used the patina on a papier mâché egg that will be added to the sculpture. Let dry.

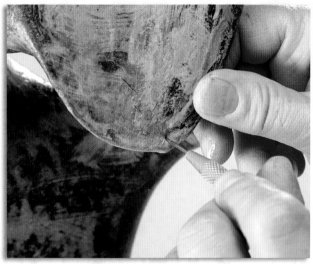

6 Pierce a hole in the nylon with a stylus or other sharp object.

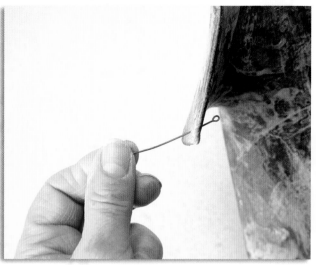

7 Insert a looped wire or pin through the hole.

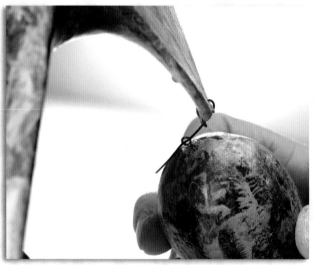

8 Insert another looped wire into the top of the egg. Attach the egg to the body of the sculpture and wrap the wire to secure.

9 Paint an 8" × 8" (20cm × 20cm) panel with a contrasting paint and patina as I've done here and use an epoxy adhesive to attach the sculpture to the base.

TIPS, TROUBLESHOOTING AND MORE IDEAS

» I applied three coats of fabric stiffener before I painted my sculpture, and I let the nylon dry completely between coats. This added more weight and strength to the piece, and it accepted paint better.

» For paint, I used Modern Master Rich Gold metallic paint. Follow the directions on the kit because different manufacturers may have different directions. I also used both blue and green patinas and very much liked the results from using both.

Vinyl Fabric

The vinyl I am using was bought at a fabric store. I found it with the upholstery fabrics, and the paper liner covering the vinyl noted it could be used to sew covers for outdoor furniture. The vinyl is fairly thick and has some pull to it. The most important notable discoveries are that it takes acrylic paints very nicely, and you can do some awesome transfers onto it. I love this stuff!

1 Cut the vinyl to a size that will fit over a stretched canvas. Wipe it down with alcohol or a damp towel to remove any dust. Fluid acrylics work especially well on vinyl. Experiment with the viscosity of the paint. Use a polymer medium to make the paint more transparent. If you add water to the paint, it will bead up on the surface. Play with some resist techniques like alcohol drops.

2 Alcohol inks are very beautiful on vinyl because of the transparency of both the ink and the vinyl. After applying alcohol inks, spread and dilute them by spraying them with alcohol.

3 Working on both sides of the vinyl adds depth and even more visual interest.

4 You could also add opaque paint to the back of the vinyl if desired.

5 Add some paint to your stretched canvas and then stretch the vinyl over it and staple the sides. You can then apply acrylic gels and add collage, gel transfers or paint to the surface. You could also cut the vinyl to the size of the panel and use gel medium to attach it to the panel.

Linoleum

Linoleum was originally made from renewable resources such as linseed oil, pine rosin, cork dust and other materials. It is still made today and is considered a "green" flooring material, but usually what you find today is polyvinyl chloride, better known as vinyl tile or flooring. Because true linoleum is not as readily available, I'll be demonstrating on tiles that may be called linoleum or vinyl. I love this stuff. It comes in different sizes as tiles or in a roll, is available in lots of colors and textures, and you can easily carve into the surface.

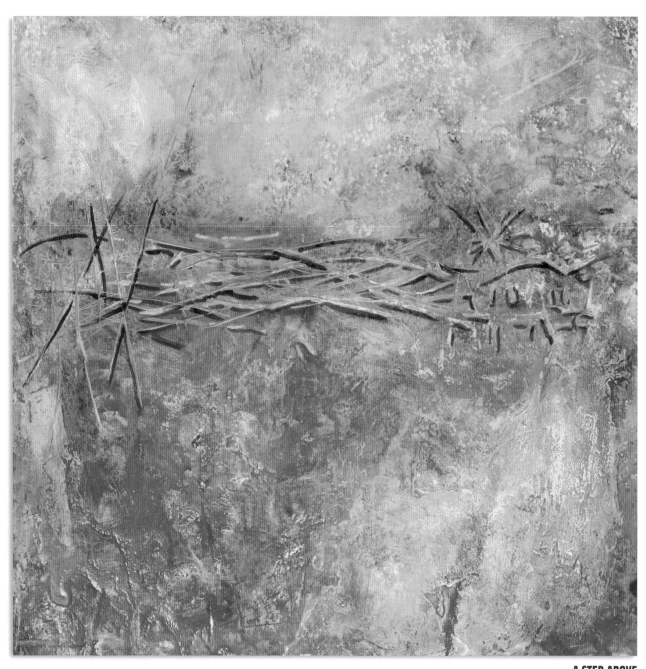

A STEP ABOVE
SANDRA DURAN WILSON
(Carved and painted linoleum vinyl tile.)

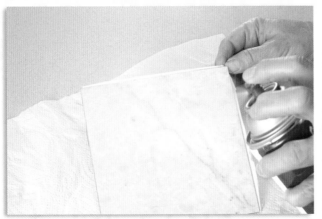

1 Clean the surface of the tile with a damp towel or alcohol wipe. The painting outcomes are going to be very different depending on the color and texture of the linoleum you have chosen. You may sand the surface if you want to create that pattern, but it isn't necessary for adhesion. You may also spray it with Dupli-Color spray to increase adhesion, but I didn't find it necessary. It may help, but you can work without it.

2 The most important thing to know about working with linoleum is that each layer of paint must dry and cure before you add the next and before you do any finish sanding. I would also suggest that you apply very thin coats of gloss gel.

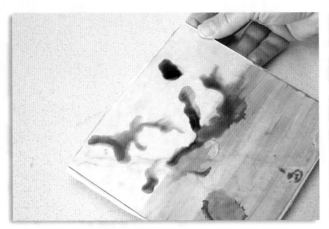

3 Layer on paint as desired. Again, remember to allow each layer to dry and cure before adding the next.

4 Use wood-carving or linoleum-carving tools to cut into the tiles. Add paint or ink to the cuts. You can even add marks with Sharpie paint pens if desired.

TIPS, TROUBLESHOOTING AND MORE IDEAS

» Some tiles have an adhesive backing that makes mounting a breeze.
» You can sand layers back to reveal underlying paint colors and even the original texture or color of the tile.
» You can, of course, do transfers onto linoleum.
» Add collage if you like.

SOUTHERN SONGS
SANDRA DURAN WILSON
*(Wax monoprint on rice paper, painted with
washes of acrylic and then mounted onto a
painted panel.)*

Visit artistsnetwork.com/alternative-surfaces for bonus demonstrations, tips, ideas and more!

19 WAX

Wax is another ancient art medium that has recently experienced a resurgence in popularity. Many great books are available on the art of encaustic painting, so I am not going to cover that technique here. But I am going to show you some wacky, offbeat and unusual ways to use wax as an alternative surface.

MATERIALS FEATURED IN THIS CHAPTER:

» acrylic paints
» alcohol inks
» barren
» box cutter or razor blade
» brayer
» electric griddle
» encaustic board or clayboard panel
» encaustic paint sticks and bars, crayons
» foam or sponge stamps
» gel matte medium
» heat gun
» inexpensive frame
» old candle pieces
» plastic wrap
» polymer medium
» rice or tissue paper
» silicone tools
» spatula
» stylus
» thermometer
» watercolor or print-making paper

TIPS, TROUBLESHOOTING AND MORE IDEAS

Take care not to overheat wax because the fumes can become toxic when overheated. Work with melted wax only in well-ventilated areas, and take precautions whenever heat is used.

Wax Monoprints—the Thick and Thin of It

I'm a printmaker. I love paper, and I love wax. I am also an acrylic painter, and I am going to show you how to combine the two. Working with wax on paper offers several advantages over the usual encaustic painting techniques: It doesn't need to be fused, and easy and practical mounting and hanging options abound. I recommend using a thin paper such as rice paper and applying wax only to a portion of the paper. The open area of the paper may then be painted with acrylics and collaged.

If I use a heavy printmaking or watercolor paper, mounting and framing options will be a bit more limited. But you still do not need to fuse or worry about temperature fluctuation, because the wax is absorbed into the paper and not merely sitting on the surface.

Working with Thick Paper

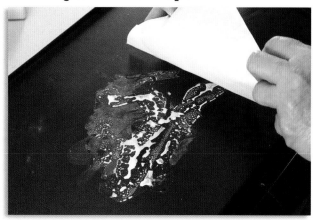

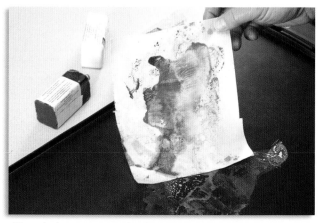

1 Heat your griddle or hot box to a temperature between 175–200°F (80–93°C). Draw on the surface of the griddle with encaustic paint sticks. You may use a spatula or silicone tool to move the wax around if you wish.

When you are satisfied with your design, place paper on the wax. Use a barren to rub the paper down. An easy way to make a barren is to wrap foil around aa piece of wood.

2 Lift the paper and admire your waxy work.

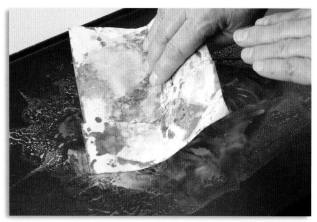

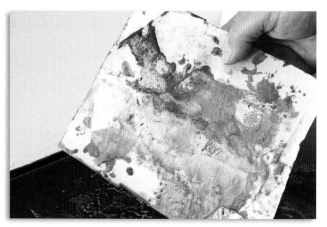

3 You may choose to add more color or not.

4 Remember that every time you place the paper back onto the heated surface, it is going to reheat and melt the wax, thereby changing your print.

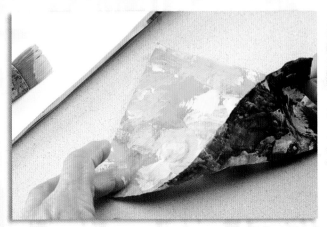

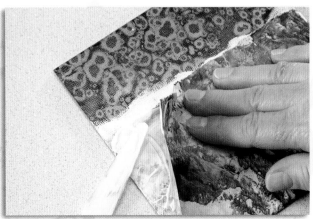

5 Use watered-down acrylic paints and/or alcohol inks to add color to both the front and back sides.

6 To add a piece of wax-painted paper to an acrylic painting, spread a thin layer of gel matte medium onto the painting. Immediately place the paper on the medium and gently rub it down. Cover the paper with plastic wrap and use a brayer to get out any air bubbles. You may wish to weight the piece and let it dry overnight.

MORE IDEAS FOR WORKING WITH THICK PAPER

When you are working with heavier papers, you can build up a surface with many layers of wax. Here are a few ideas:

» You can use foam or sponge stamps to apply hot wax to the paper.
» You may also put the paper directly onto the heated surface and draw on it with your wax. This is a fun way to get words or particular shapes into your work.
» When the wax is cool, you can scratch into it using a stylus or similar tool.

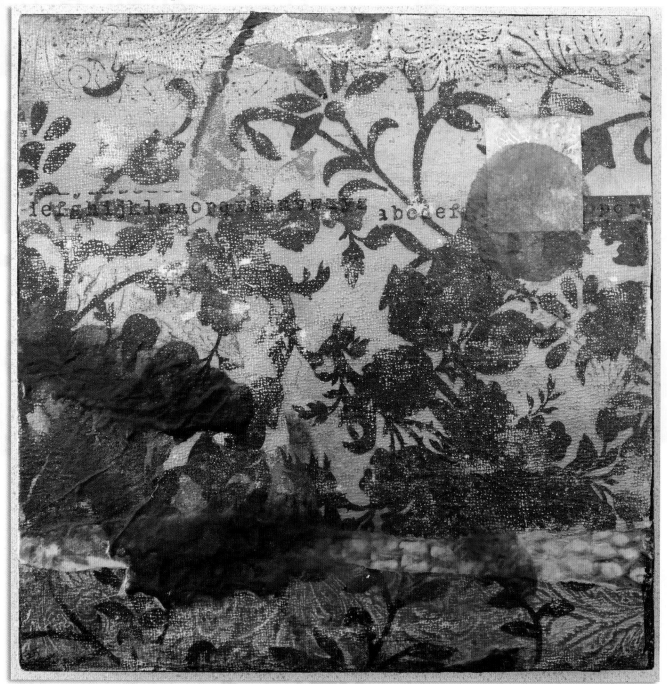

THROUGH THE MIST
SANDRA DURAN WILSON

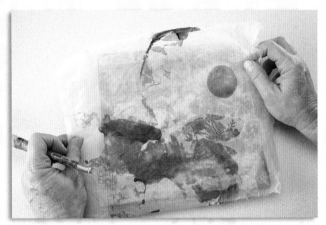

To add a layer of thin wax-painted rice paper or tissue paper to an acrylic painting, first apply a layer of polymer medium to the painting. Place the paper onto the medium.

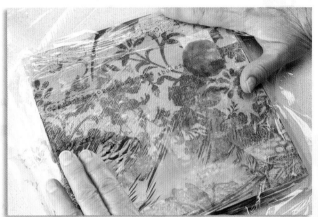

Place plastic wrap on top of the paper. Rub down on it and then remove the plastic. Let dry, trim any overlapping edges and finish as desired.

TIPS, TROUBLESHOOTING AND MORE IDEAS

» You may purchase encaustic bars or sticks from suppliers like R&F or Enkaustikos.
» I use only beeswax and not petroleum products for the painting process.
» Never use synthetic fiber cloths or brushes; use only natural materials like cotton and bristle brushes.
» Use tools that are heat resistant.
» Wax fumes can be toxic at temperatures higher than 200°F (93°C).
» Never leave heated tools unattended. Use caution.
» You can see the colors of the melted wax better if you work on a silver griddle rather than a black one.
» Wrap aluminum foil over a block of wood to make a barren.
» Clean up is a breeze. Remove most of your good encaustic wax from the surface. With the surface still hot, apply a thin coat of paraffin and wipe off with an old rag.

MOUNTING IDEAS

» Attach thin papers to a panel or canvas with gel medium.
» Make scrolls on rice paper. They can be draped over a wooden dowel and attached to the ceiling or wall.
» Mount heavy wax applications under glass.
» Use really strong magnets to hold the work in place on metal.

Wild and Wacky Crayon Painting

This piece ranks up there with the shaving foam technique from *Surface Treatment Workshop* or dancing on your art from *Mixed Media Revolution* as some of the most fun you can have making art!

While this technique is undeniably fun, it's not archival or anything close to archival. I keep this piece hanging in my studio. It reminds me to try the unexpected.

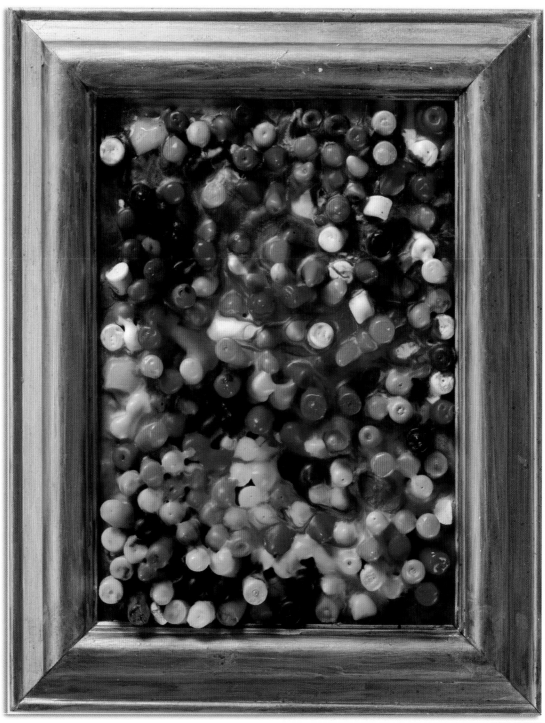

HOT STUFF
SANDRA DURAN WILSON
(Melted crayons on panel.)

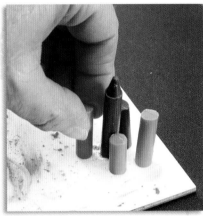

1 Remove the paper from the crayons and break or cut them into assorted lengths.

2 Melt your old candle pieces or wax onto the board using the heat gun to create a base. I am using an Ampersand Encaustic panel. Make sure you are working on a nonflammable surface and have good ventilation.

3 Stand crayons up onto your board. This is the hardest part. It helps to put the panel on your electric griddle so the wax is soft and can act as a glue to hold the pieces in place. Work with a color theme or just place them at random.

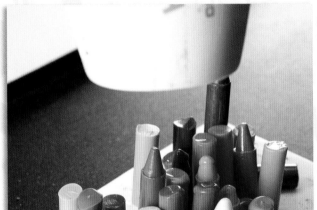

4 Carefully use your heat gun to melt the crayons. It is that simple.

5 Put a frame on your crayon landscape and hang it up.

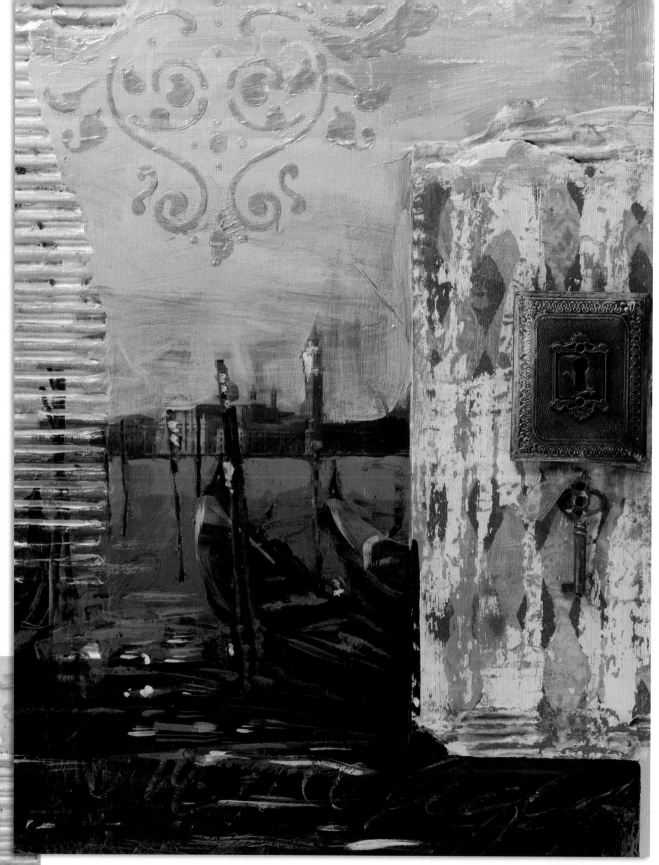

BEEN THERE, BE BACK
DARLENE OLIVIA MCELROY
(Cardboard, key, frame, keyhole on panel.)

Visit artistsnetwork.com/alternative-surfaces for bonus demonstrations, tips, ideas and more!

20 FOUND OBJECTS & ODDS & ENDS

Nothing should ever go to waste. Instead of throwing out that old dress, paint it and then mount it. If you're remodeling your house and replacing your doors, well, why not use the old ones as art surfaces? That old floor lamp can be part of a standing sculpture. The list goes on: doll parts, old serving trays, vintage objects, anything that isn't tied down. Searching for found art elements is much like a treasure hunt, and as your collection of finds grows, you will probably want to organize it into some order. Like working a puzzle, your imagination and the found objects together will create a new story.

MATERIALS FEATURED IN THIS CHAPTER:

» acrylic paint
» cardboard
» collage materials including dimensional objects
» found and collected objects
» gesso
» glue (white glue, epoxy, hot glue and others appropriate for what you are adhering)
» paintbrush
» patina kit
» sandpaper
» scissors
» stencils
» wooden block keyhole hanger
» wrapped canvas or panel

Preparing Your Surface
Make sure your surface is clean and sand if necessary so the paint will stick. In some cases, you may want to prime the surface with gesso.

Mounting/Hanging
This should be in your thoughts while constructing the piece. Perhaps part of your sculpture is the base, or you might buy a premade sculpture mount to finish off your sculpture. If it is a wall piece, you might want to mount it to a frame or use a piece of wood with a keyhole for hanging. Throughout the book, we have shown you several ways to mount art. When I am in galleries, I always look at how other artists present and hang their art.

Transfers
This will vary greatly depending on your surface. Transfers will work best on flat surfaces.

Painting and Drawing
This can vary with your surface. If oil-based paint is already on the object, you should continue with oil paints or pastels, or prepare the surface by sanding. Otherwise, acrylics should work in most cases. If there is not enough tooth to draw on the surface, consider applying a light layer of clear gesso or absorbent ground.

Aging
Sanding, rusting, patinas and weathering paint all give you an aged looked. See *Surface Treatment Workshop* for more ideas.

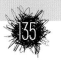

3-D Cardboard Surface

You can find objects to use as a surface or make your own using scrap cardboard, which is easy to find. You can tear off some of the outer layer, showing the corrugated interior for interest, build it up by gluing cardboard pieces on top of each other, cut out windows and glue objects to it.

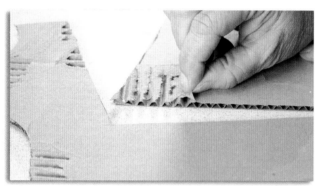

1 Cut or tear a variety of cardboard shapes.

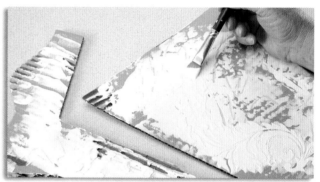

2 Gesso the shapes and glue them together with white glue.

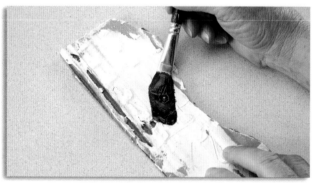

3 Paint, stencil and collage as desired.

4 Add dimensional objects using appropriate adhesives.

5 Apply white glue to the back of a wooden block keyhole hanger and attach it to the back of your surface.

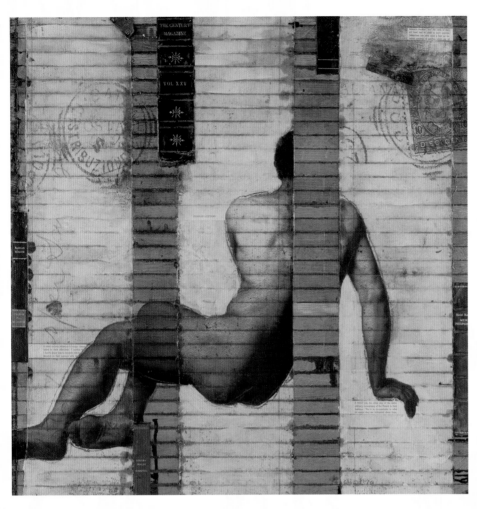

(H)OMBRE
DARLENE OLIVIA MCELROY
(Rolltop desktop, canvas, book spines,
image transfers, drawing and painting.)

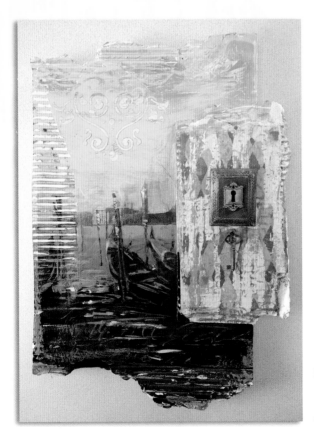

BEEN THERE, BE BACK
DARLENE OLIVIA MCELROY
(Cardboard, key, frame, keyhole on
panel.)

Found-Object Sculpture

The most important element used in a found-object sculpture is the glue, especially if you have a large disparity of materials. A quick-drying, two-part epoxy or silicone glue will work with most materials. Other important tools are clamps, nails, bolts, screws, wire and string, depending on your vision. These items work well as both functional and decorative elements.

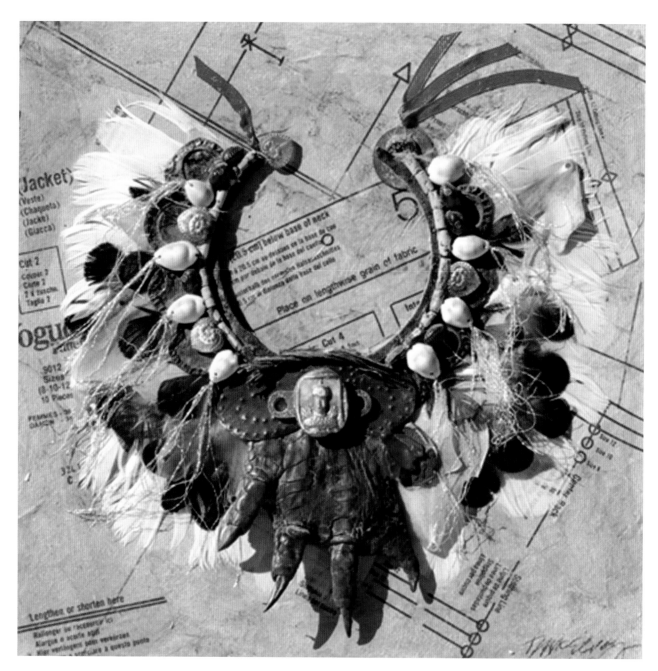

COLLAR OF A PAST CIVILIZATION
DARLENE OLIVIA MCELROY
(Shells, bottle caps, armadillo claw, feathers and beads.)

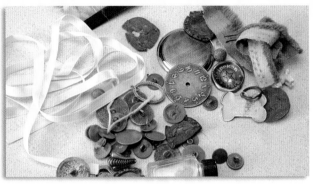

Gather the elements you will use to tell your visual story.

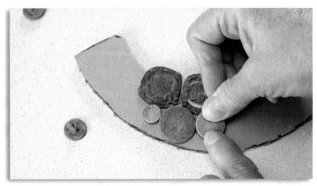

Start gluing the elements together, thinking about balance both visually and structurally.

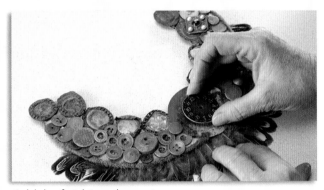

Add the finishing elements.

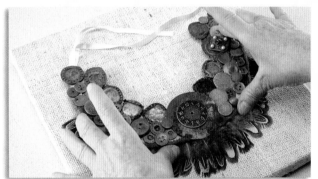

When you have finished gluing the elements together, apply paint or patina or leave as is. With a hot glue gun, add glue to the back side and mount, to a substrate if desired.

TIPS, TROUBLESHOOTING AND MORE IDEAS

If you are using metal elements, sand the back side of each object to give it tooth so it will grip better with the glue. If in doubt about which glue to use, visit *thistothat.com*, a great website for information on glues.

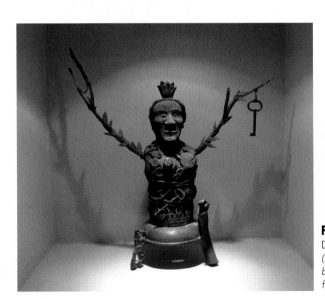

FALSE GOD
DARLENE OLIVIA MCELROY
(Key, buttons, typewriter keys, oil lamp base, wood figure, twigs, miscellaneous found objects.)

Resources

Art Supply or Hobby and Craft Stores:
Acrylic gels and pastes, acrylic paint, painting surfaces (canvas and panel), metal leaf, Styrofoam, stamps, stencils, Paperclay, glues, casting molds, clip frames, EnviroTex resin, plaster of Paris, plaster gauze, patina paint kits, Krylon sprays, StazOn ink, alcohol inks, spray paint, cell foam, Pébéo specialty enamel paints, wax supplies and more

Hardware and Home Improvement Stores:
Plexiglas, glass, metal, flashing (galvanized tin), sandpaper, metal shim, spray foam, spray paint, shellac spray, plastic painter's tarp, joint compound, Venetian plaster, vinyl tiles, stone tiles, wire mesh for gabion, unsanded grout, premixed adhesive grout, Plexiglas cutting tools, E6000 adhesive

Fabric Stores:
Fabric remnants, vinyl, faux leather and suede, Lutradur, interleafing

Grocery Store:
Bleach, aluminum foil, Citra Solv

Auto Supply:
Dupli-Color Adhesion Promoter

Frame and Sign Shops:
Plexiglas, Dibond and aluminum

Office Supply:
Transparencies

Printable Paper-Backed Fabric Sources:
jacquard.com

Leather Sources:
tandyleatherfactory.com
leatherunltd.com

Clay for Monoprints:
Clay or ceramic studio supply

Wood Veneer Samples:
veneersupplies.com

Mica Sources:
iceresin.com
ashevillemica.com

Mica Powder Sources:
artistcraftsman.com
delphiglass.com

Miscellaneous Sources:
Grafix specialty papers: grafixarts.com
Waterslide transfers: papilio.com
Venetian plaster: modernmasters.com
ClayShay: avesstudio.com
Resin: eti-usa.com/envirotex-lite
GAC products: goldenpaints.com
Chartpak, specialty papers, art supplies, wax supplies: dickblick.com

About the Authors

SANDRA DURAN WILSON

Sandra Duran Wilson is influenced by scientific concepts, the dream state and the nature of materials. She loves to experiment and push the limits of paints, mediums and surfaces. She enjoys the tactile aspect of paint and what it can do, and she has always been an inventor of new ways to use existing tools and materials. She loves to paint ideas; to make them visible, beautiful and abstract so others may enter them and create their own reality. She lives and creates in Santa Fe, New Mexico, with Mark, her husband and collaborator, and a bevy of feline friends.

DEDICATION:

To my brothers, Don and John, for always daring me and challenging me to keep up with them. I learned to take risks, to trust my inner voice and to face my fears. I keep challenging myself to this day. Thank you for the dare.

ACKNOWLEDGMENTS:

I would like to thank my writing partner, Darlene, for bringing a different perspective to our creative process. Big thanks to Tonia Davenport, you have been with us from the beginning of this journey and what a great one it still is; to Kristy Conlin, our editor, thanks for weaving our techniques together and putting it all together so beautifully; to Christine Polomsky, you always keep us laughing and you are very much appreciated; thank you to the F+W team that makes the magic happen; and thank you to Brittany VanSnepson for helping us stay organized during the photo shoot.

I would like to acknowledge and thank my galleries, collectors and students for without you this journey would not be possible. Thank you to my amazing husband, Mark. You are always my inspiration.

DARLENE OLIVIA MCELROY

Darlene Olivia McElroy comes from an old New Mexico family of storytellers and artists. She began making art the first time she found a wall and a drawing instrument. Her grandfather, a painter on Catalina Island, was her mentor and taught her to play and experiment with art. Darlene attended the Art Center College of Design in Pasadena, California, and has worked as an illustrator both in the United States and in Paris. She went from creating illustration traditionally to becoming one of the first nationally recognized digital illustrators in the late 1980s. Darlene lives and works in Santa Fe, New Mexico, where she paints, teaches, writes and enjoys a delightfully chaotic life with her husband, Dave, and their four dogs, Bernie, Bella, Taco and Zola.

DEDICATION:

To Dave, my loving husband and centering force. Thank you for your support and for inspiring my dreams in color. To Bonnie Teitelbaum and the Blonde Bombshells, whose creative and fun influence always shows up in my art.

ACKNOWLEDGMENTS:

Big thanks to our critique group who added their touches to our Pass-It-Around project and lived through our travels of creating a book.

On the incredible F+W team, we would like to thank Tonia Davenport for getting this book on board; Kristy Conlin, our wild and crazy editor; and Christine Polomsky, our talented photographer. You all made it fun and easy once again.

We would also like to thank our students, who gave us the inspiration to create this book. You kept us exploring and experimenting, and we hope to keep coming up with more innovative ways to play.

Index

Alternative Art Surfaces. Copyright © 2014 by Darlene Olivia McElroy and Sandra Duran Wilson. Manufactured in China.
All rights reserved. No part of this book may be reproduced in any form or by any electronic or mechanical means including information storage and retrieval systems without permission in writing from the publisher, except by a reviewer who may quote brief passages in a review. Published by North Light Books, an imprint of F+W Media, Inc., 10151 Carver Road, Blue Ash, Ohio, 45242. (800) 289-0963. First Edition.

Other fine North Light Books are available from your favorite bookstore, art supply store or online supplier. Visit our website at www.fwmedia.com.

media

18 17 16 15 14 5 4 3 2 1

DISTRIBUTED IN CANADA BY FRASER DIRECT
100 Armstrong Avenue
Georgetown, ON, Canada L7G 5S4
Tel: (905) 877-4411

DISTRIBUTED IN THE U.K. AND EUROPE
BY F&W MEDIA INTERNATIONAL LTD
Brunel House, Forde Close, Newton Abbot, TQ12 4PU, UK
Tel: (+44) 1626 323200, Fax: (+44) 1626 323319
Email: enquiries@fwmedia.com

DISTRIBUTED IN AUSTRALIA BY CAPRICORN LINK
P.O. Box 704, S. Windsor NSW, 2756 Australia
Tel: (02) 4560-1600, Fax: 02 4577 5288
Email: books@capricornlink.com.au

ISBN 978-1-4403-2944-9

Edited by Kristy Conlin
Designed by Elyse Schwanke
Production coordinated by Jennifer Bass
Photography by Christine Polomsky and Kris Kandler

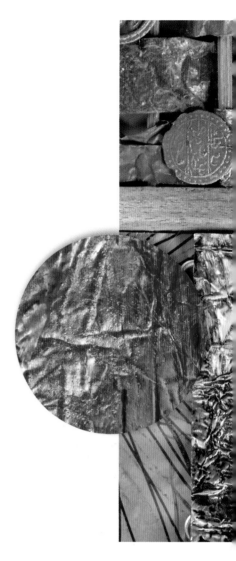

METRIC CONVERSION CHART

To convert	to	multiply by
Inches	Centimeters	2.54
Centimeters	Inches	0.4
Feet	Centimeters	30.5
Centimeters	Feet	0.03
Yards	Meters	0.9
Meters	Yards	1.1